IMAGES
of America

GLENDALE
1940–2000

D1571597

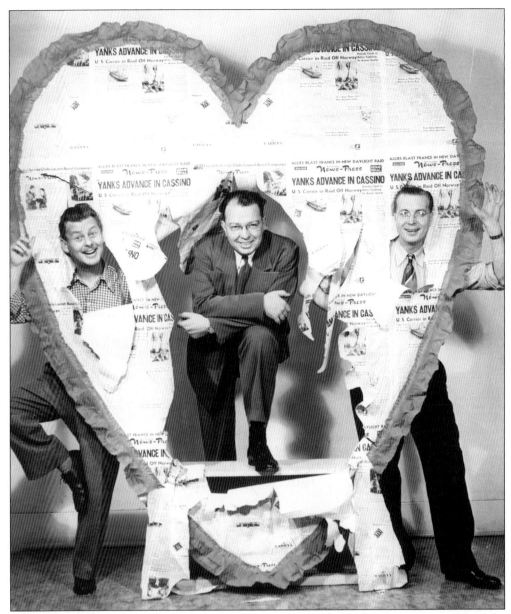

Glendale News-Press editor and publisher Carroll W. Parcher brings breaking news to Glendale. He became mayor in 1977, many years after his father held the position in 1906. (Courtesy of the Special Collections Room, Glendale Public Library.)

ON THE COVER: This 1962 photograph shows the Glendale skyline, looking north from the top of the six-story Security Bank building on Broadway. The Glendale Federal building and the Alex Theatre spire are the only tall structures along the boulevard. (Courtesy of the Special Collections Room, Glendale Public Library.)

IMAGES
of America

GLENDALE
1940–2000

Juliet M. Arroyo

ARCADIA

Published by Arcadia Publishing
Charleston SC, Chicago IL, Portsmouth NH, San Francisco CA

Printed in the United States of America

Library of Congress Catalog Card Number: 2005936982

For all general information contact Arcadia Publishing at:
Telephone 843-853-2070
Fax 843-853-0044
E-mail sales@arcadiapublishing.com
For customer service and orders:
Toll-Free 1-888-313-2665

Visit us on the Internet at www.arcadiapublishing.com

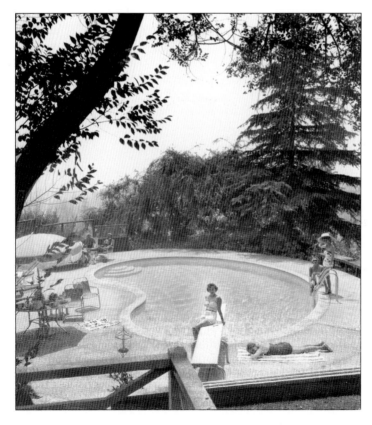

This 1957 photograph, taken at a Glendale hillside home, was displayed in the living section of the *Glendale News-Press*. (Courtesy of the Special Collections Room, Glendale Public Library.)

CONTENTS

ACKNOWLEDGMENTS

I would like to acknowledge past and present Glendalians who have told me numerous stories of Glendale through mini oral histories, including Larry Zarian, Bob McFall, Jim Paglioso, and Carol Dougherty. I would like to acknowledge George Ellison, longtime Glendale resident and library assistant in the Special Collections Room of the Glendale Public Library, for helping me find material on a multitude of Glendale topics housed in over 200 file folders. I would like to thank Glendale Public Library director Nancy Hunt-Coffee and assistant director Cindy Cleary for their assistance and support. I would like to thank Carroll W. Parcher for documenting Glendale history in his book *Glendale Area History* and his writings about Glendale published in the *Glendale News-Press* and Bruce Herman for help dating photographs. I would like to thank the photographers of the *Glendale News-Press*, the *Los Angeles Daily News*, and the former *Glendale Ledger* who took several of the images used in this book and now housed as prints or negatives in the Special Collections Room of the Glendale Public Library. Press photographers like Salvador Felix, Cecil Yates, and Raymond Watt provided professional images of Glendale throughout the years. I wish to thank photojournalist Ara Oshagan for sharing his images of Glendale Armenians and their stories. I would like to thank Yana Kafedjiyska for her help gathering the photographs used in this book and Valerie Bermudez for her technical expertise with digital imaging. I would like to thank family members and former Glendalians Bruce Petty, Joshua Arroyo, Ed Arroyo, Clyde Simmons, and Greg Simmons. I would like to especially thank the Glendale Historical Society and the Historical Society of the Crescenta Valley for their kind support and the work they do to highlight and preserve community identity and character.

INTRODUCTION

Each period of Glendale's past can be seen today through its buildings, people, businesses, organizations, and institutions. By 1940, the city had grown significantly while still retaining its Midwestern feel. But as the freeways tore through the community, the Galleria opened, and Brand Boulevard became lined with high-rises, Glendale became a different community. The city government reflected the conservative politics of residents with a long history of fighting taxation and big government. Many who lived in Glendale were employed in the nearby aviation industry and were connected to manufacturing in the early years and then retail and service industries in the later years. Various minority groups with conservative feelings took a liking to Glendale's multitude of churches, safe and clean streets, family orientation, peaceful environment, and good schools. Mexican American and Latino groups have always remained a sizable minority population in Glendale, with larger numbers coming in the early 1970s. Waves of Armenian immigrants came in significant numbers beginning in 1975, mostly from homes in Armenia and diaspora lands such as Lebanon and Iran. Asians, mostly Filipinos and Koreans, made Glendale home when they were attracted by churches and schools established here. The city's African American population has increased significantly since 1970, but by 2000 only represented 1.3 percent of the population.

The city's north-south divide has existed since the 1940s. The southern area, representing the older part of town, was strategically located as an entry point for newcomers. A large part of La Crescenta, an independent community with a history as long as Glendale's, was annexed into the city in the early 1950s. In 1986, the Glendale Unified School District reported 63 spoken languages, with Spanish, English, Armenian, and Korean as the most dominant. In 1987, Glendale was reported to be the third largest financial center in the state, after Los Angeles and San Francisco, due to its strong redevelopment program that took advantage of its location. Explosive development in the 1980s led to traffic congestion that frustrated many residents. With more ethnic groups in the city, the population shifted from Republican-dominant to Democratic-leaning. By 2000, 67 percent of the population over five years old spoke a language other than English at home. The city government grew by providing more services and began to sponsor community events that local organizations once provided in the past.

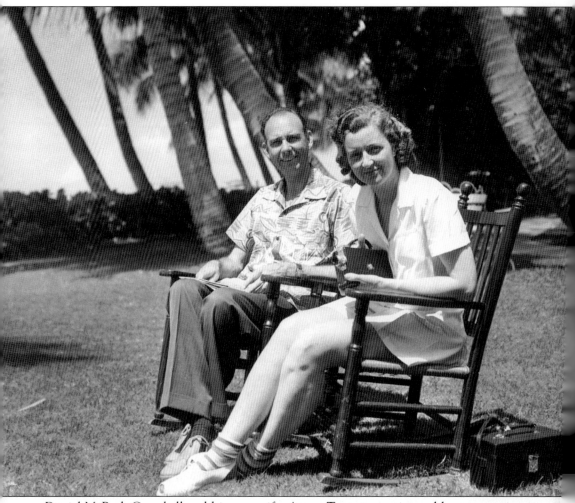

Daniel McPeak Campbell and his new wife, Agnes Tupper, are pictured honeymooning in Honolulu, Hawaii, in 1940, lounging on the Waikiki terrace of the Halekulani hotel. Their visit from Glendale, California, was reported in the local newspapers. Campbell's father, Dan Campbell Sr., was a trusted friend of Leslie C. Brand, who assisted in early banking and improvement ventures in Glendale. Dan Jr. was a prominent business owner and leader in the community, taking pride in Glendale's growth. Agnes was a respected Glendale schoolteacher. (Courtesy of Sally A. MacAller.)

One

A CITY EMERGES
1940–1950

Glendale had a population of 82,582 in 1940 and grew 15.9 percent by the end of the decade. In the early 1940s, World War II affected the city like the rest of the country and the world. Men and women went off to war while Glendale sponsored a pickup, collecting donated scrap metals needed to make war machinery. Holy Family Catholic Church organized a newspaper-recycling effort to raise funds, and city rationing was initiated to save resources for the war. Glendale and Southern California war industries grew, especially aviation. Grand Central Airport and the Curtis-Wright Technical Institute trained pilots and aircraft mechanics and became the center of Glendale industries. Unfortunately, there was a darker side as well, with longtime Glendale residents of Japanese descent being sent to the Manzanar internment camp in 1942. By the end of the war, though, Glendale was no longer a community of homes but a city with a strong commercial and industrial base. Brand Boulevard also became a large central shopping district. Many newcomers made Glendale their home after the war, including young single men and women venturing west looking for new opportunities. Aviation industries such as Lockheed drew a new, large workforce to the region and a new population to Glendale.

It was a decade of evolution for Glendale. Debate over what route the new Crosstown Freeway should take started in 1940, dividing businessmen who wanted it to follow near Colorado Boulevard and engineers who wanted the route to be more direct following the Verdugo wash. In 1941, Glendale completed its first unit of a new power plant on San Fernando Road. Temple Sinai was established on Pacific Avenue in 1948. The Glendale Welfare Council was formed in 1949, providing non-governmental social services. The Glendale Chamber of Commerce moved to its new location at Harvard and Louise Streets in 1949, but by this time it was not the power broker like in the past, and city council became more influential community-wide. With new people moving into Southern California, new housing was built on undeveloped lots in the foothill subdivisions of the 1920s or as second units behind homes built in the earlier periods. Newcomers included Irvine Robbins and his brother-in-law Burton Baskin, who started their first ice cream shop in Glendale in 1945. A local housing development company, started in 1934 by architect and builder Alice Lee Gregg, constructed many of the homes across north Glendale during the 1940s.

This 1942 street scene shows early San Fernando Road at the Broadway intersection, with the Southern Pacific Railroad tracks in the background. This area became the heavy industrial zone for the region, fueled by aviation-related businesses. (Courtesy of the Special Collections Room, Glendale Public Library.)

The new home of the Glendale YWCA in this 1940 photograph was built near the corner of Lexington Drive and Glendale Avenue. The Glendale chapter was formed in 1926 and kept moving to larger spaces until its new facility was completed in 1939. (Courtesy of the Special Collections Room, Glendale Public Library.)

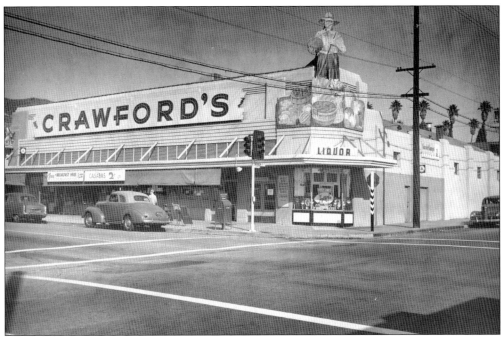

The Crawford market, pictured here around 1940, was located on the northeast corner of Central Avenue and Stocker Street. A larger supermarket with the same name later replaced it. (Courtesy of the Special Collections Room, Glendale Public Library.)

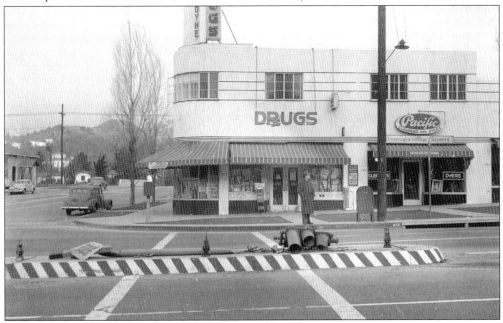

The Rossmoyne drugstore, pictured here in 1943, was on the corner of Mountain Street and Verdugo Road. This police file photograph documents a fallen traffic signal. In the 1940s, Glendale had at least one drugstore on every major intersection. This corner served as the shopping area for Rossmoyne Village until the buildings were demolished in the 1960s to make way for the Civic Auditorium parking lot. (Courtesy of the Special Collections Room, Glendale Public Library.)

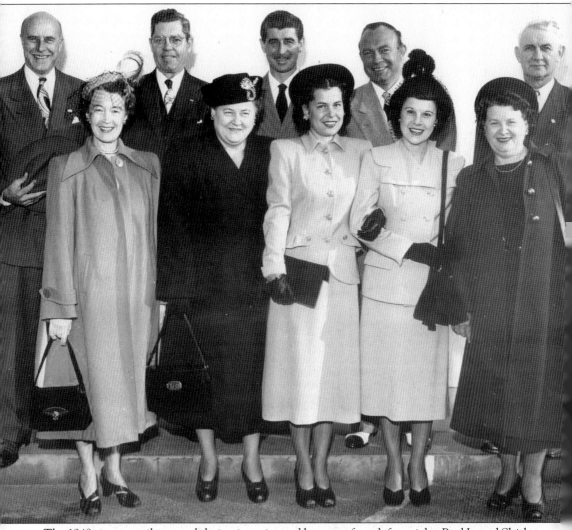

The 1948 city councilmen and their wives pictured here are, from left to right, Paul L. and Shirley Burkhard, George A. and Beryl Campbell, Robert C. (Bob) and Francis Wian, Harold (Hal) E. and Bernice Wright, and George R. and Vesta Wickham. (Courtesy of the Special Collections Room, Glendale Public Library.)

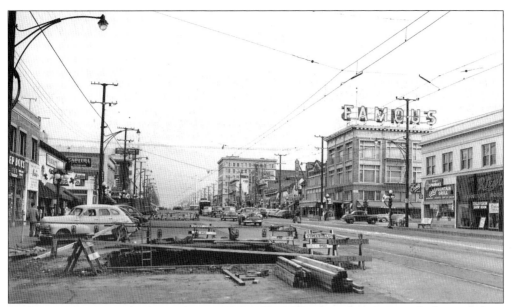

Underground street work is being done in 1949 on Brand Boulevard, as this view looks north from Harvard Street, with the Famous department store pictured at right. (Courtesy of the Special Collections Room, Glendale Public Library.)

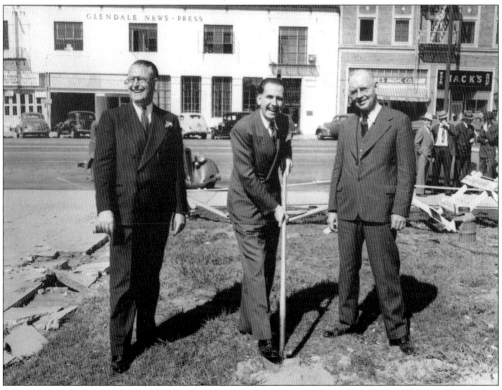

Officials break ground in 1940 for the first modern building in Glendale, which will house the Valley National Bank on Brand Boulevard just south of Lexington Drive. The *Glendale News-Press* building is in the background. (Courtesy of the Special Collections Room, Glendale Public Library.)

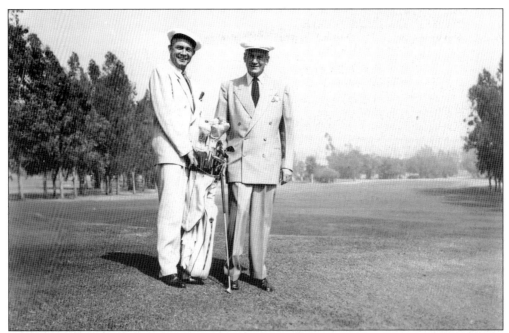

Councilman Hal Wright, at left, caddies for councilman Merrill Baird at the Oakmont Country Club in 1949. Hal Wright was a well-known insurance agent in Glendale, and Merrill Baird was a distinguished architect and charter member of the Verdugo Club whose favorite sport was golf. (Courtesy of the Special Collections Room, Glendale Public Library.)

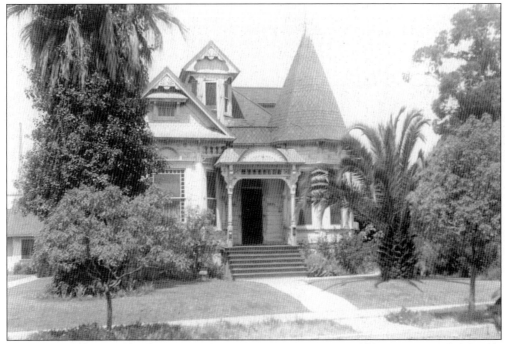

The home of Edgar and Alletia Goode on Cedar Street is pictured here in 1940. The Goode family was important to early Glendale development, but they left the area in 1915. (Courtesy of the Special Collections Room, Glendale Public Library.)

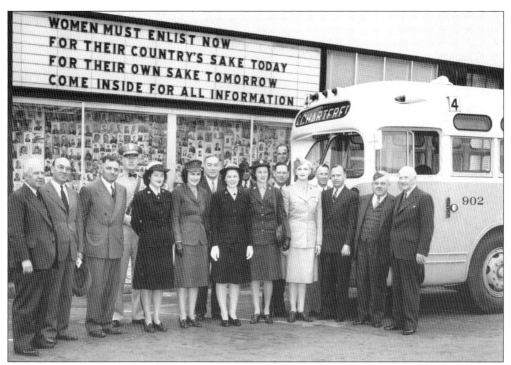

Servicewomen pose around 1942 in front of the *Glendale News-Press* exhibitorium on Brand Boulevard that encouraged women to enlist in the military. (Courtesy of the Special Collections Room, Glendale Public Library.)

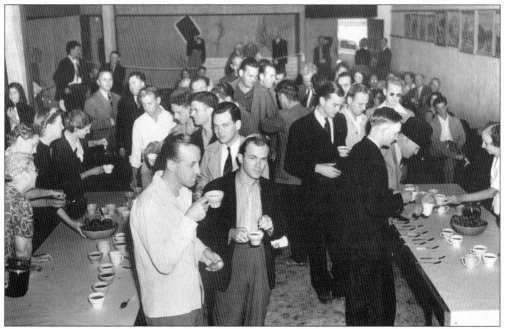

Glendale selectees are offered breakfast on August 31, 1942, by the Glendale Army Mothers and Wives Club inside the *Glendale News-Press* exhibitorium before they leave for the Induction Center in Los Angeles. (Courtesy of the Special Collections Room, Glendale Public Library.)

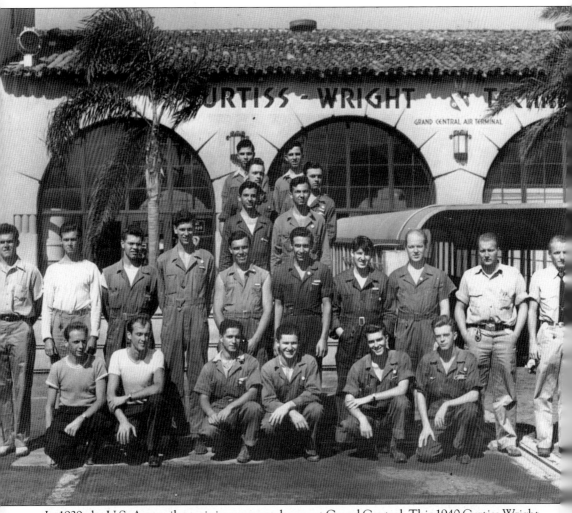

In 1939, the U.S. Army pilot training program began at Grand Central. This 1940 Curtiss-Wright Technical Institute class of trained pilots and airplane mechanics pose in front of the Grand Central Air Terminal. (Courtesy of the Special Collections Room, Glendale Public Library.)

In the 1990s, the Glendale Post Office was restored with funding from the federal government and was listed on the National Register of Historic Places. The inside of the post office, pictured here around 1946, contains exquisite detailing including coffered ceilings. (Courtesy of the Special Collections Room, Glendale Public Library.)

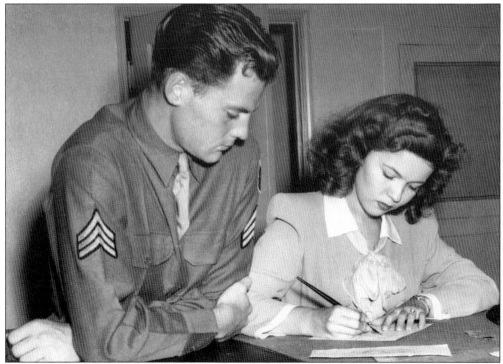

Seventeen-year-old actress Shirley Temple completes the marriage license application with her fiancé, Sgt. John Agar Jr., looking over her shoulders at the county court offices in Glendale in 1945. (Courtesy of the Special Collections Room, Glendale Public Library.)

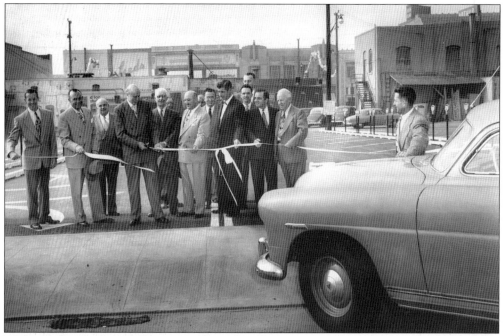

These Glendale city councilmen proudly cut the ribbon to open the city's first parking lot, located on Maryland Avenue between Broadway and Wilson Avenue, c. 1949. (Courtesy of the Special Collections Room, Glendale Public Library.)

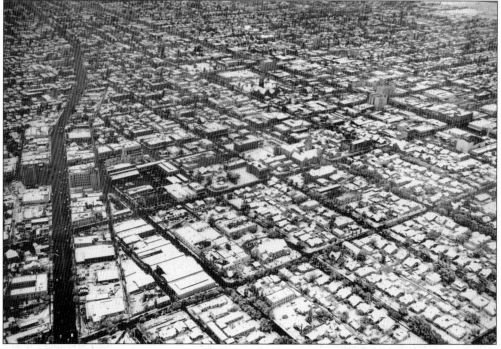

Snow fell over most of the Montrose and Glendale areas in January 1949, providing a great opportunity for Glendalians to take pictures and send to relatives back in the Midwest and East Coast. (Courtesy of the Special Collections Room, Glendale Public Library.)

The end of the Red Car line stopped at the top of Brand Boulevard, pictured here in 1949. In 1950, when rail service was decreasing nationally, Pacific Electric invested in motor coaches and diesel buses and began phasing out train service until it was completely discontinued in Glendale by 1955. By the early 1950s, Glendale's streets were crowded with buses, streetcars, and automobiles. (Courtesy of the Special Collections Room, Glendale Public Library.)

The Shriners hold their parade along Brand Boulevard in the late 1940s. The Shrine Club of Glendale organized in 1921 and was part of the large Los Angeles membership. (Courtesy of the Special Collections Room, Glendale Public Library.)

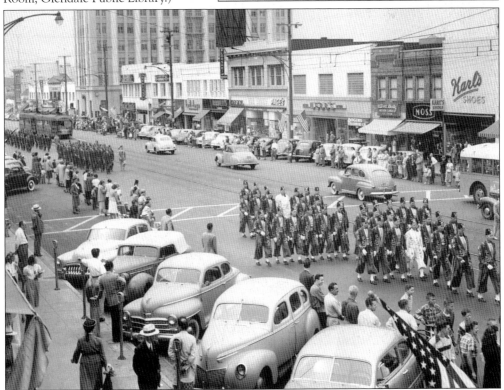

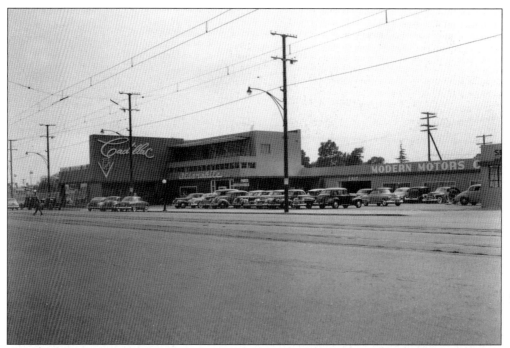

The Glendale Cadillac dealership was part of the Modern Motors Company at 1225 South Brand Boulevard, as pictured in this late 1940s photograph. (Courtesy of the Special Collections Room, Glendale Public Library.)

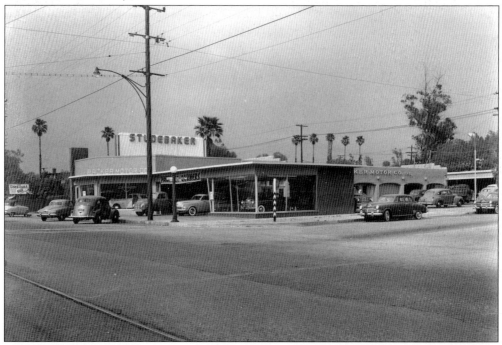

The Studebaker dealership, part of the Packer Motor Company, was also located along South Brand Boulevard, as pictured here in the late 1940s. (Courtesy of the Special Collections Room, Glendale Public Library.)

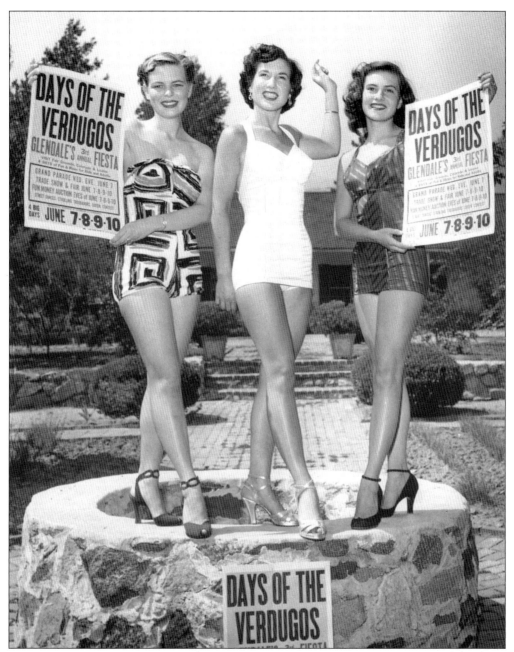

Beauty queens stand on the old well at the Casa Adobe de San Rafael in 1949 to promote the third-annual Days of the Verdugos festival. The festival started in 1947, was organized by the junior chamber of commerce, and included a dinner dance, a Miss Glendale beauty pageant, and a grand parade down Brand Boulevard. (Courtesy of the Special Collections Room, Glendale Public Library.)

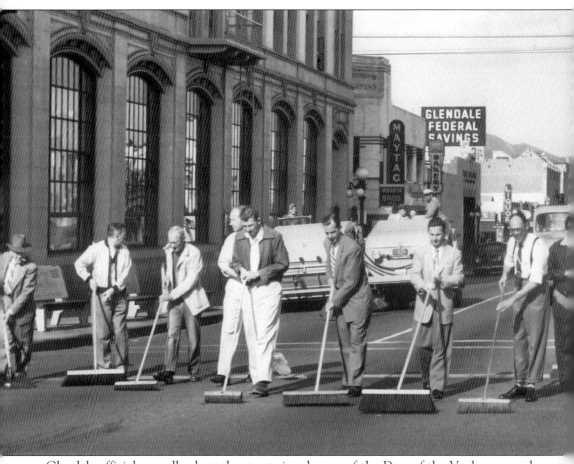

Glendale officials proudly clean the streets in advance of the Days of the Verdugos parade. They are pictured here sweeping eastward down Broadway, with Bank of America and Glendale

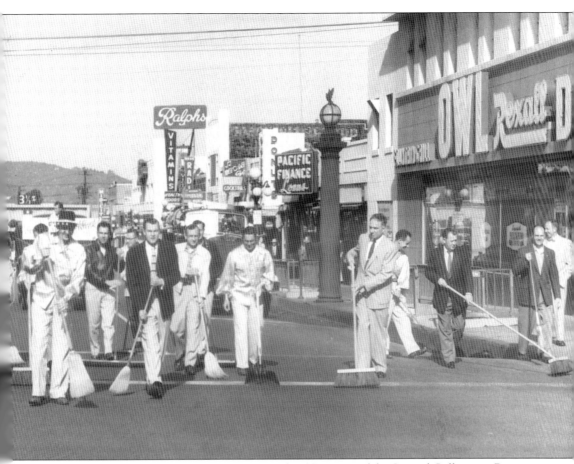

Federal at left and the Ralph's grocery store at right. (Courtesy of the Special Collections Room, Glendale Public Library.)

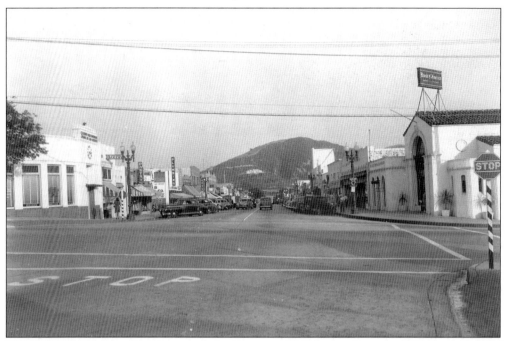

The Montrose Business District served the Crescenta Valley area since the 1910s, and many of the early buildings were constructed in the 1920s. This street scene shows Honolulu Avenue in 1940, looking east from Oceanview Boulevard. (Courtesy of Mike Lawler.)

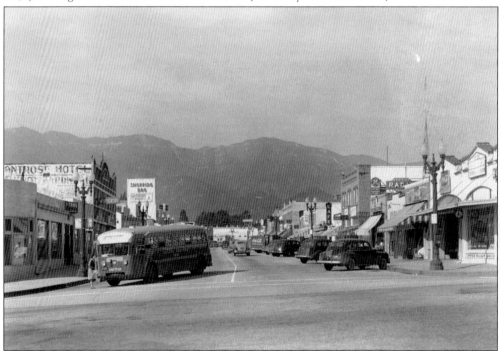

A Pacific Electric bus picks up a passenger on Honolulu Avenue in the Montrose Business District in this view looking west from Verdugo Road in 1940. The Montrose Theatre marquee and the Shopping Bag grocery store sign are pictured at left. (Courtesy of Mike Lawler.)

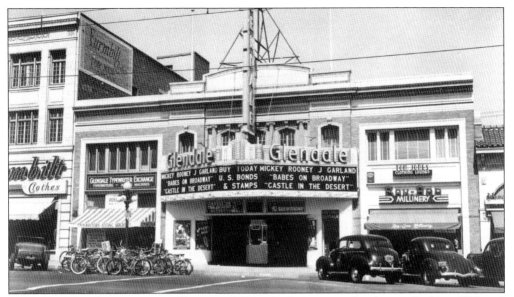

The Glendale Theatre, pictured here in 1940 with shops on each side, was built in 1919 and competed with the Palace Grand Theatre. It was the premier hall in Glendale until the Alexander Theatre opened in 1925. (Courtesy of the Special Collections Room, Glendale Public Library. From the B'Hend and Kaufmann Archives.)

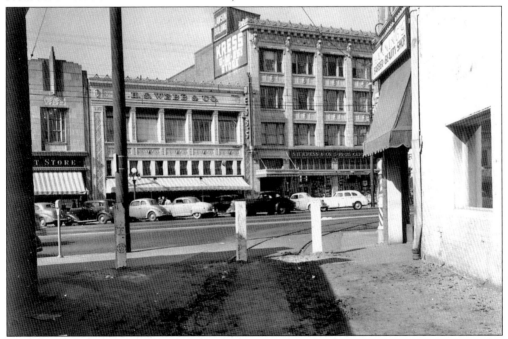

This 1949 photograph of the Five and Ten Cent Store at left, the second Webb's Store in the middle, and the Lawson Building at right shows three of Glendale's most remarkably designed commercial buildings on the west side of Brand Boulevard south of Wilson Avenue. Both the Webb's Building and the Lawson Building were designed by noted Glendale architect Alfred Priest. The abandoned freight tracks of the Pacific Electric are pictured in the foreground. (Courtesy of the Special Collections Room, Glendale Public Library.)

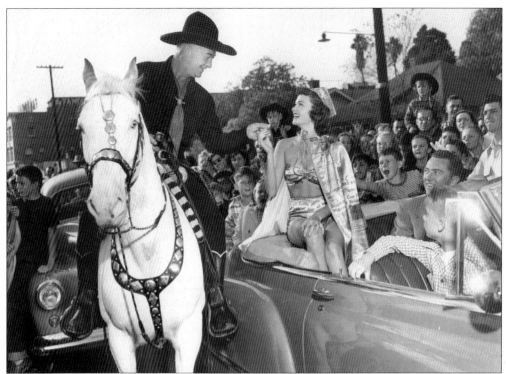

The popular Hopalong Cassidy greets Miss Glendale News-Press, shrouded in newsprint, as he rides in the 1949 Community Chest parade. Lined up along Harvard Street between Maryland Avenue and Louise Street, a crowd of enthusiastic fans surrounds the two. (Courtesy of the Special Collections Room, Glendale Public Library.)

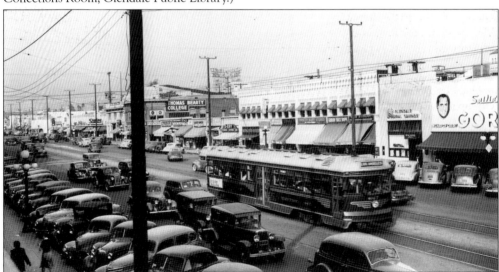

This 1940 photograph of Brand Boulevard shows the east side of the street between Broadway and Wilson Avenue, the central business district since the city was incorporated in 1906. An early office of Glendale Federal is pictured at right, and the Alexander Theatre roof sign is on the left. Refurbished streetcar 667 is headed south to the subway terminal in downtown Los Angeles. (Courtesy of the Special Collections Room, Glendale Public Library.)

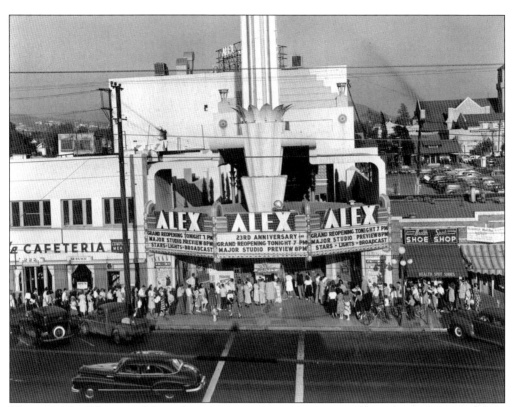

The new Alex Theatre celebrated its 23rd anniversary in 1948 and its grand reopening following a redesign. In the 1940s, the old Alexander vaudeville house transformed into the Alex art deco movie palace with a tall neon spire that lit the night sky. Major studio previews were common, sometimes with appearances by movie stars. (Courtesy of the Special Collections Room, Glendale Public Library.)

A visiting group of regional library and parks officials, along with Glendale community leaders, get a tour of the former estate of Mr. and Mrs. Leslie C. Brand (now in the hands of the city as a gift from them). Mostly due to funding questions, a vision of its future use was in question from the time Mrs. Brand died in 1945 until the city installed a library in 1956. (Courtesy of the Special Collections Room, Glendale Public Library.)

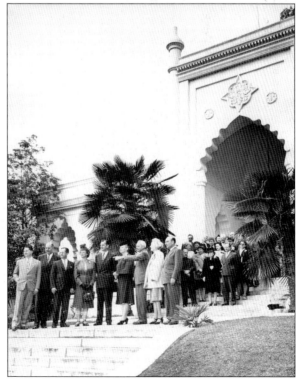

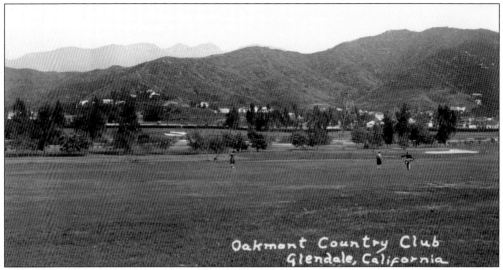

The Oakmont Country Club was developed in 1920 and laid out among residential subdivisions in the area. The original clubhouse was an English Tudor design destroyed in a 1946 fire. The early Oakmont Country Club was organized and operated by and open to an exclusive group of businessmen. (Courtesy of Mike Lawler.)

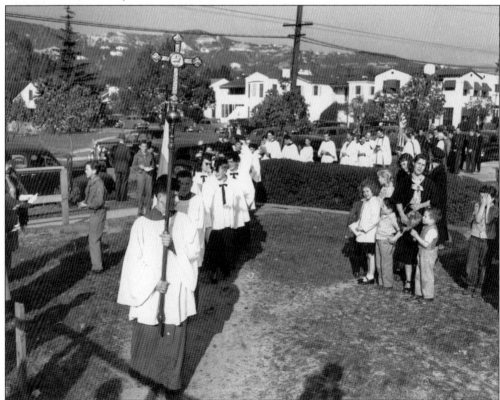

On February 8, 1948, St. Marks Church provided a ceremonial groundbreaking event at its north Brand Boulevard location. The Verdugo Mountains are in the background. (Courtesy of the Special Collections Room, Glendale Public Library.)

Two

A GREAT PLACE TO GROW UP
1950–1960

Glendale's population of 95,702 in 1950 grew by 24.8 percent by the end of the decade. The city was characterized as self sufficient with a small-town feel. Community groups provided the networking for social, business, and philanthropic activities, and public dances provided nightlife for residents. Crime was low, with a few burglaries and cases of public drunkenness reported. Plenty of movie theatres provided constant entertainment for local kids, riding their bikes to see the latest releases. The Boy Scouts, teaching young men to be good citizens, was so popular that it led to construction of a new headquarters for the local chapter in 1953. The residential character and scenic natural environment made Glendale a great place to grow up, as children had plenty of play areas outside the home.

Work started on the Golden State Freeway in 1955 and was completed in 1957 for the section along Glendale's western end, and construction started on the Glendale Freeway in 1956. The new Brand Library branch opened in 1956 after the city council spent 10 years trying to decide how to fund its improvements. Council members became more influential over a city determined to remain independent of larger, looming governmental forces. Many influential political and business decisions were made at the local men's Verdugo Club founded in 1950.

Not too many years later, the city's first female mayor was elected in 1957. The annexation of La Crescenta in 1951 added six square miles to Glendale's territory and was the only significant physical growth of the city since the 1920s. In 1955, the Glendale Sanitarium and Hospital modernized with a new five-story addition, and in the same year the old Physician and Surgeon Hospital changed its name to Memorial Hospital of Glendale. The Glendale Unified School District also modernized nearly all of its schools, beginning in this period. Glendale College completed a modernization program from 1953 to 1957, including the new Campus Center Building. A parking ordinance was adopted in 1955 to require on-site parking with new development. The planned Grand Central Industrial Park anticipated 150 new buildings on the 180-acre industrial tract, the largest in the San Fernando Valley. In the mid-1950s, the Pacific Electric streetcars stopped running through Glendale and the rest of the region, leaving various bus companies as the only public transportation in the area.

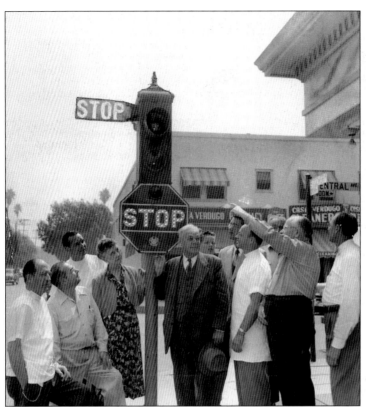

A group gathers to see the last of the mechanical-arm traffic signals to be removed in Glendale at the intersection of Central Avenue and Stocker Street. The Casa Verdugo pharmacy at the northwest corner is in the background in this 1952 photograph. (Courtesy of the Special Collections Room, Glendale Public Library.)

A boxing program spearheaded by one individual was set up to teach young boys self-defense and discipline during the 1950s and 1960s. (Courtesy of the Special Collections Room, Glendale Public Library.)

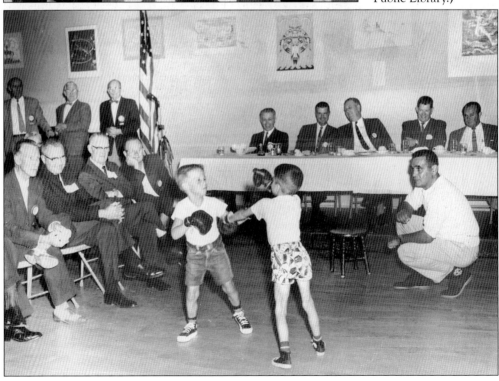

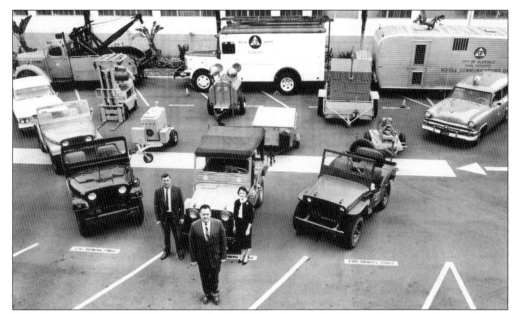

The city started a civil defense program in 1942 with an air-raid warden system. Later the city hired a chief civil defense officer and purchased a wide range of equipment, which is displayed in this photograph taken in front of the central control center, (Courtesy of the Special Collections Room, Glendale Public Library.)

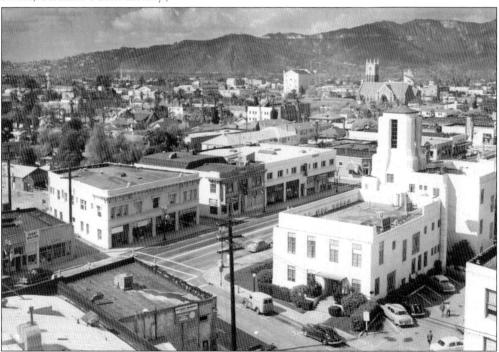

Glendale City Hall, pictured here around 1953, was located on the northwest corner of Broadway and Howard Street. Howard Street was later vacated to create a city hall campus. The east wing of the structure contained the shell of the original city hall built in 1912. (Courtesy of the Special Collections Room, Glendale Public Library.)

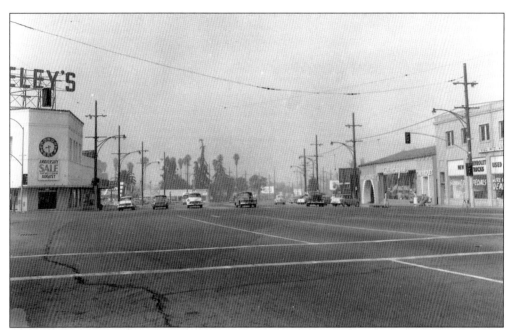

Brand Boulevard, looking south from the San Fernando Road intersection, is pictured here in 1955, before a grade separation with the Southern Pacific Railroad tracks was constructed. The George Seeley's Furniture Company, claiming in the 1960s to be Glendale's oldest and largest furniture store, is pictured at left, with the Allen Gwynn auto dealership at right. (Courtesy of the Special Collections Room, Glendale Public Library.)

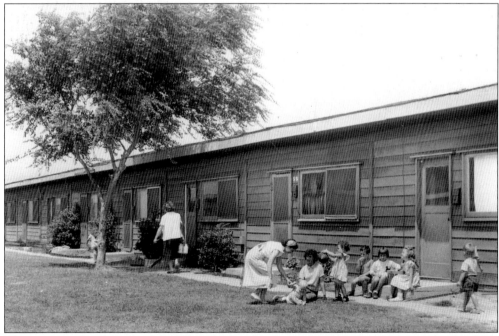

The city owned and operated the Glen Vet Court, a housing project for 99 veteran families built side by side within 20 long buildings. Pictured here in 1953, it was located at the end of Colorado Street west of San Fernando Road. (Courtesy of the Special Collections Room, Glendale Public Library.)

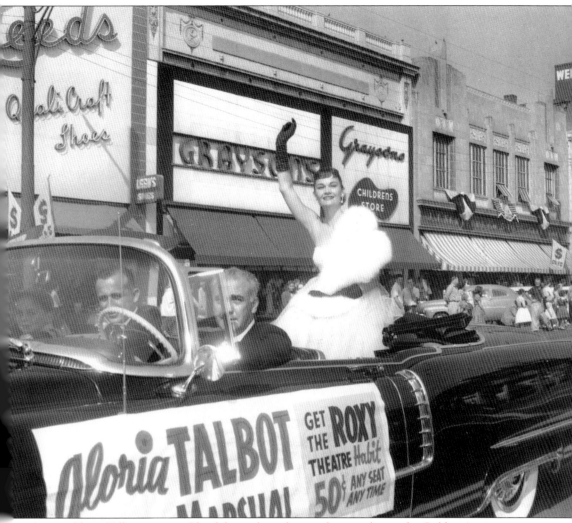

Actress Gloria Talbot waves to Glendalians along the parade route during the Golden Anniversary parade on October 13, 1956, marking the city's 50th anniversary. The east side of Brand Boulevard south of Wilson Avenue is pictured in the background, with the former Palace Grand shops in the middle. (Courtesy of the Special Collections Room, Glendale Public Library.)

A crowd gathers around the Glendale Southern Pacific depot in 1959 to greet Soviet leader Nikita Khrushchev's train. The train stopped very briefly before heading to northern California. (Courtesy of the Special Collections Room, Glendale Public Library.)

Actress Terry Moore and her mother, Mrs. Koford, are pictured in this 1954 photograph inside their Glendale home. (Courtesy of the Special Collections Room, Glendale Public Library.)

The Herbert Hoover High School administration building is pictured here in 1957. It was the only remaining portion of the original Hoover High School when the school was rebuilt in the late 1960s. (Courtesy of the Special Collections Room, Glendale Public Library.)

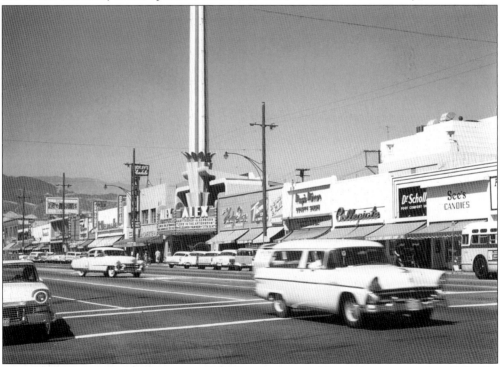

The wide Brand Boulevard characterized the shopping area of Glendale, as pictured in 1957. The Alex Theatre spire rises out of frame in the background. By this time, the old Pacific Electric tracks had been removed. (Courtesy of the Special Collections Room, Glendale Public Library.)

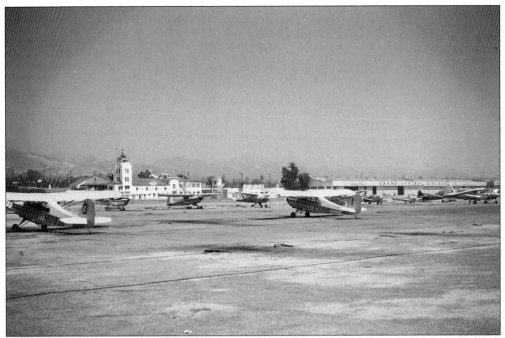

In 1955, Grand Central was closed to air traffic and development began for a light industrial center, with modern concrete buildings appearing one by one. This 1957 photograph shows the old runway before demolition. (Courtesy of the Special Collections Room, Glendale Public Library.)

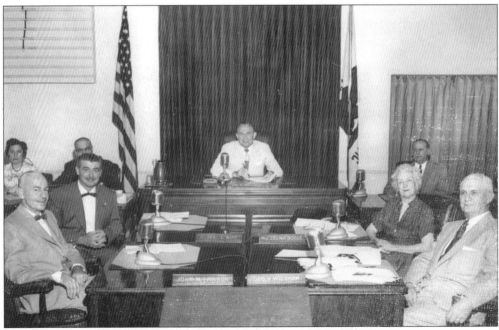

The high-profile Glendale City Council of the 1950s, pictured from left to right, included John Lawson, Robert Wian, Hal Wright, Zelma Bogue, and George Wickham. (Courtesy of the Special Collections Room, Glendale Public Library.)

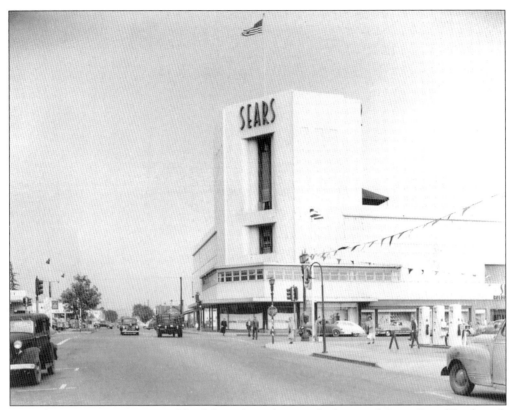

Sears department store came to Glendale in the early years, finding its place on Brand Boulevard. In 1937, it built the large flagship building on Central Avenue in this 1951 photograph. By this time, commercial uses were found along Central Avenue, a trend set by the relocation of Sears to the area. (Courtesy of the Special Collections Room, Glendale Public Library.)

Former Glendale mayor Bob Wein crowns Mr. and Mrs. Wading Pool in 1954 at the Verdugo Swim Stadium next to the Civic Auditorium. (Courtesy of the Special Collections Room, Glendale Public Library.)

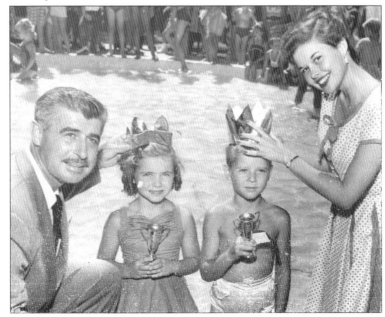

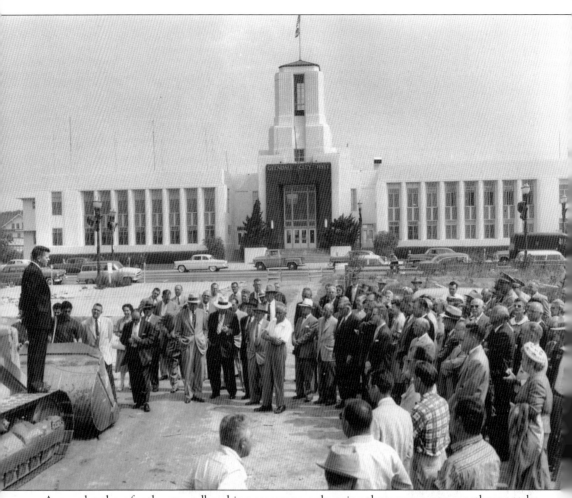

A crowd gathers for the groundbreaking ceremony welcoming the new county courthouse to be built directly across the street from the Glendale City Hall, marking this area of Glendale as the center for government facilities. Construction was completed in 1959. (Courtesy of the Special Collections Room, Glendale Public Library.)

The city recreation center for retired persons was built in the 1950s, as pictured here showing Central Park in the background before the Central Library was constructed in 1972. It is now called the Adult Recreation Center and is a lively activity location for Glendale seniors. (Courtesy of the Special Collections Room, Glendale Public Library.)

Seniors play shuffleboard at the Adult Recreation Center for retired persons. Today it also offers a meal program to seniors. (Courtesy of the Special Collections Room, Glendale Public Library.)

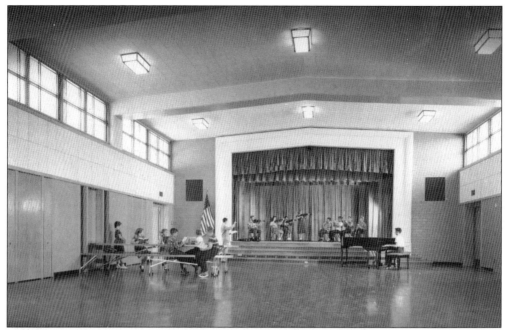

The Jefferson "cafetorium" was the first such facility to be built in the Glendale school system. The idea was that the auditorium and cafeteria would share one space with lunch tables that fold into the walls when the facility was used for assembly. (Courtesy of the Special Collections Room, Glendale Central Library. Photograph by Julius Shulman.)

The educational administration building of Glendale schools was housed in the former Wilson School, as pictured in this c. 1950 photograph, until a larger structure was built on the same site in 1972. (Courtesy of the Special Collections Room, Glendale Public Library.)

An assembly of concerned residents anticipated to be displaced by the planned Crosstown Freeway (Ventura Freeway) gathers in the Glendale High School Auditorium in 1959 to hear about freeway plans. (Courtesy of the Special Collections Room, Glendale Public Library.)

Ten-year-old Steve Mitchell of Glendale gleefully lights a firework (left) with full approval of Fran Turner, a Glendale policeman, as a disconsolate Richard Nye, nine, and Los Angeles deputy sheriff F. Gunnick look on (right). Fireworks are legal in Glendale but not in Los Angeles County. The white line in the center of this c. 1955 photograph divides the city from the county. (Courtesy of the Special Collections Room, Glendale Public Library.)

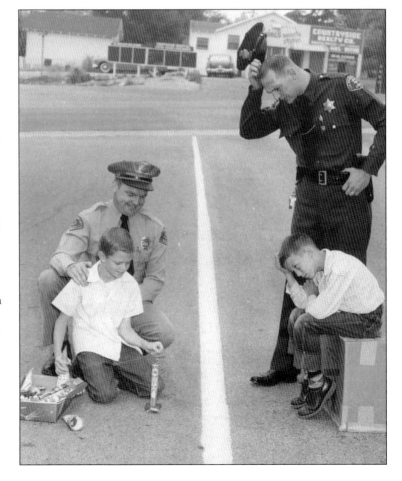

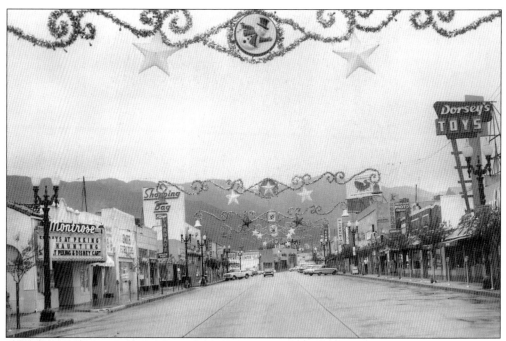

Like Brand Boulevard, Honolulu Avenue in Montrose was decorated for the Christmas season as pictured here around 1959. The Montrose Theatre pictured at left was destroyed by fire in the 1980s and became a parking lot. (Courtesy of the Special Collections Room, Glendale Public Library.)

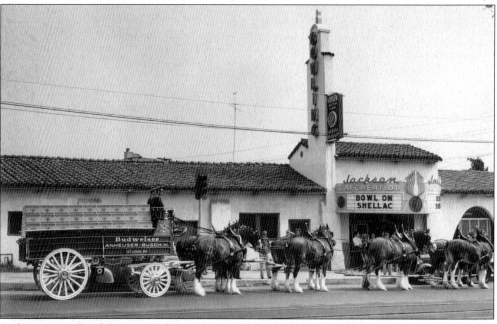

Anheuser Busch celebrates a half-century in the brewing business with a parade of Clydesdale horses that left St. Louis, Missouri and toured the West Coast with a stop across Glendale on March 15, 1950. The wagon team takes a break in front of Jackson Bowl on 416 South Glendale Avenue; the wagon being hauled was built in 1902. (Courtesy of the Special Collections Room, Glendale Public Library.)

The two sons of Joseph Paglioso, at right, pose with Mayor Zelma Bogue at the grand opening of the Thriftymart in the Glendale Plaza shopping center. The land was the boyhood homesite of the two men when their father served as foreman since 1891 of what was Judge Ross's ranch of citrus and olives. (Courtesy of Jim Paglioso.)

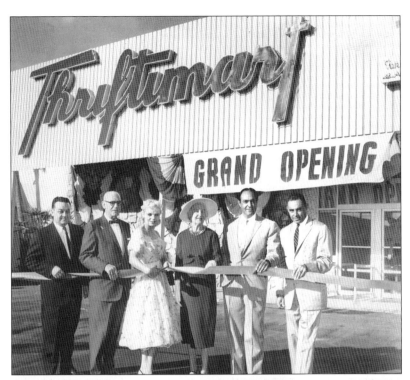

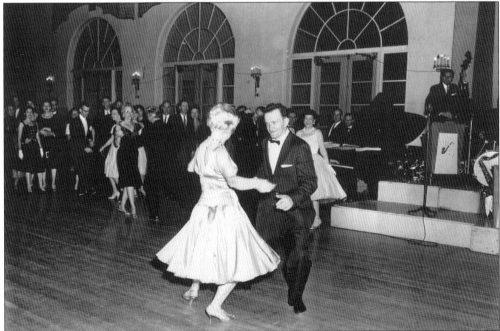

The Civic Auditorium hosted many dances for several decades with big bands that played for the large crowds. Glendale had a very quiet nightlife with limited activities for young adults and public dances were popular since not much else was available locally. A couple dances to the band music in this c. 1957 photograph. (Courtesy of the Special Collections Room, Glendale Public Library.)

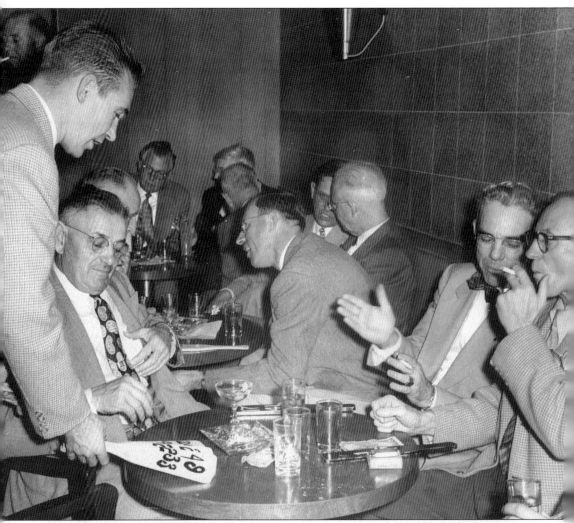

Men of the Verdugo Club relax and socialize in this c. 1957 photograph. The Verdugo Club was formed in 1950 to offer Glendale businessmen the opportunity to meet during lunch and network and was modeled after the exclusive Jonathan Club in Los Angeles. John Lawson, who later was elected to the Glendale City Council, started the club. Membership was highly limited and women were not allowed as members, nor were they allowed inside the club until the late 1970s. The club was very popular and any influential business or political man was a member. The club died in the mid-1990s for several reasons, including the elimination of the tax deduction for business lunches. (Courtesy of the Special Collections Room, Glendale Public Library.)

Earl Idman, a parking meter service man, displays the city's new change machine used to give five nickels for a quarter for the new parking meters installed at the Maryland Avenue municipal parking lot. (Courtesy of the Special Collections Room, Glendale Public Library.)

Employees of the city's planning division gather around the reception area as pictured in this 1956 photograph. Although Glendale had a zoning ordinance, a comprehensive plan, and a planning commission in the 1920s, it did not have a coordinated planning program until 1947 when a director was appointed. Other city divisions at this time included commercial, engineering, street, fire, legal, library, parks and recreation, police, water and electric, building, clerk, treasurer, civil service, and a city physician—all under the administration of the city council and city manager. (Courtesy of the Special Collections Room, Glendale Public Library.)

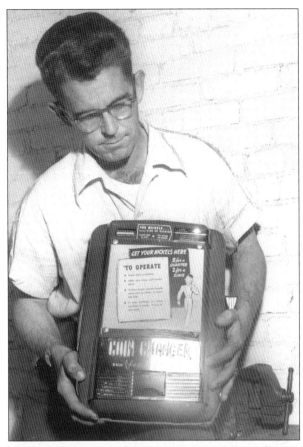

Glendale city and school offices combined efforts to offer a multitude of recreational classes for kids of all ages, especially activities in city parks for children out of school during the summer. (Courtesy of the Special Collections Room, Glendale Public Library.)

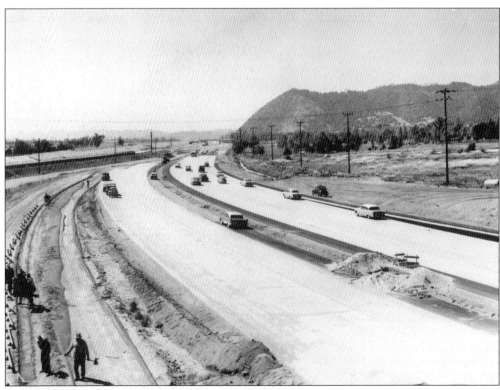

The Golden State Freeway (Interstate 5), through the western edge of Glendale, is nearly completed in this *c.* 1956 photograph looking south. (Courtesy of the Special Collections Room, Glendale Public Library.)

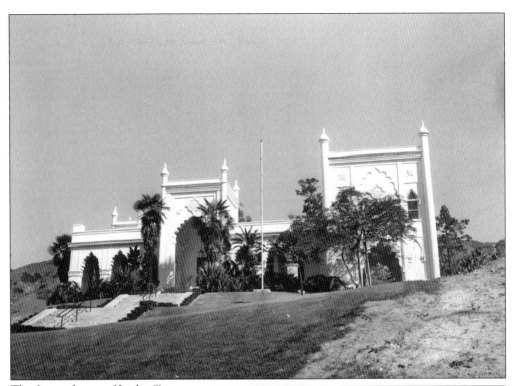

The former home of Leslie C. Brand was willed to the city to serve as a library. It was not until 1956 that the home was modified and used in that capacity. (Courtesy of the Special Collections Room, Glendale Public Library.)

Mayor Zelma Bogue and city manager C. E. "Gene" Perkins discuss the transformation of the Brand parklands into a municipal park owned and operated by the city. Zelma Bogue had the distinction of being Glendale's first female mayor after serving in several community organizations. Gene Perkins had been Glendale's city manager for over 20 years and helped to established Glendale's fiscally sound reputation. (Courtesy of the Special Collections Room, Glendale Public Library.)

The boy's police band play for the city council inside the lobby of Glendale City Hall. (Courtesy of the Special Collections Room, Glendale Public Library.)

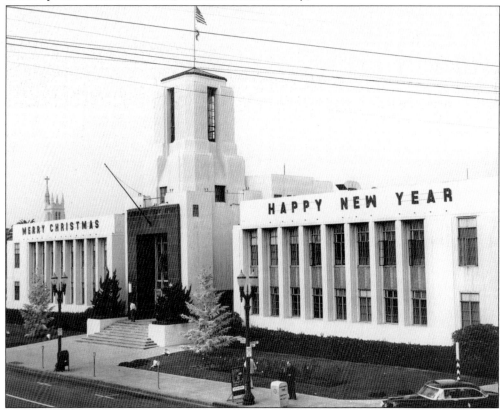

City hall was regularly decorated for the Christmas season during the 1950s. The lighted decorations provided a warming aura at night. (Courtesy of the Special Collections Room, Glendale Public Library.)

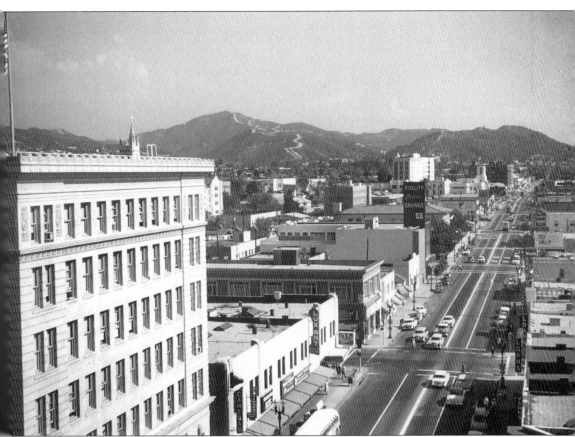

This photograph shows a street view looking east along Broadway around 1956, with the Maryland Avenue intersection in the foreground and city hall and the public services building in the background at Glendale Avenue. Bob's diner is visible at the northeast corner of Broadway and Maryland Avenue. (Courtesy of the Special Collections Room, Glendale Public Library.)

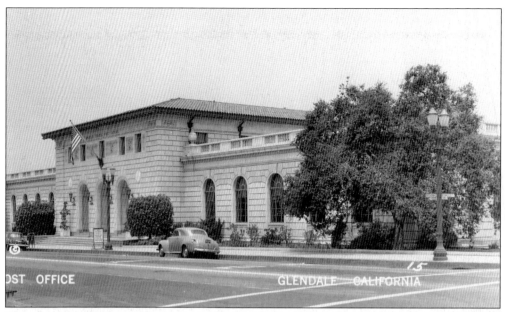

The main Glendale Post Office was completed in 1934 as a Works Progress Administration (WPA) building and still serves as the city's main post office. This postcard view of the post office was taken around 1950. (Courtesy of the Special Collections Room, Glendale Public Library.)

Modern medical buildings like these structures were built near the top of Brand Boulevard. (Courtesy of the Special Collections Room, Glendale Public Library.)

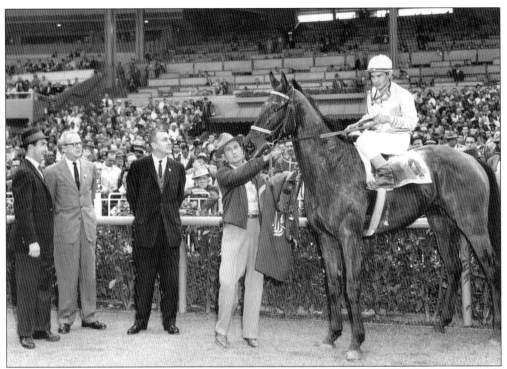

Edward Callister "Cal" Cannon (third from left), a Glendale city councilman and one-time mayor from 1955 to 1962, visits the Santa Anita Race Track. (Courtesy of the Special Collections Room, Glendale Public Library.)

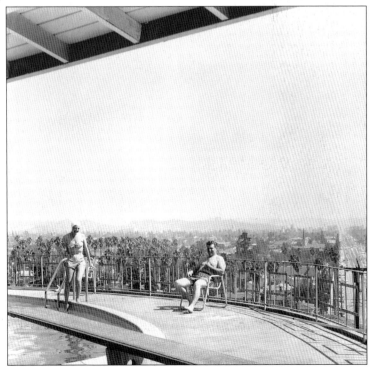

Residents of a hilltop home have a spectacular view that overlooks Brand Boulevard in 1957. (Courtesy of the Special Collections Room, Glendale Public Library.)

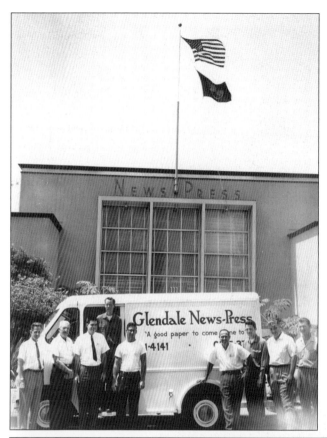

The *Glendale News-Press* headquarters, pictured here in the 1950s, was built in 1948 at 111 North Isabel Street. It moved from its Brand Boulevard location to be closer to city hall and the news that came out of city hall. (Courtesy of the Special Collections Room, Glendale Public Library.)

Members of the Glendale Planning Commission get a tour of hillside land in 1957 in anticipation of a new development. Much of the news in the 1950s reported concern over loss of hillside open space to new development. (Courtesy of the Special Collections Room, Glendale Public Library.)

The interior of a modern Glendale home was featured in a 1957 edition of the living section of the *Glendale News-Press*, displaying the black-and-white vinyl floor. (Courtesy of the Special Collections Room, Glendale Public Library.)

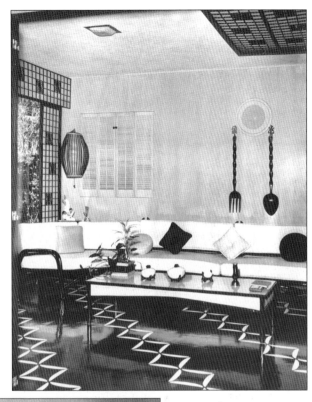

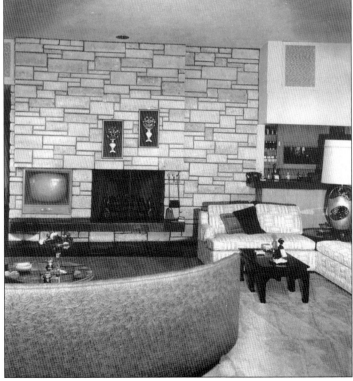

Another interior of a Glendale home in 1957 displays a block-walled fireplace with an inset television set. (Courtesy of the Special Collections Room, Glendale Public Library.)

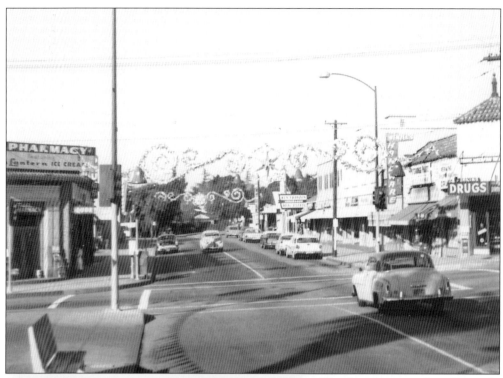

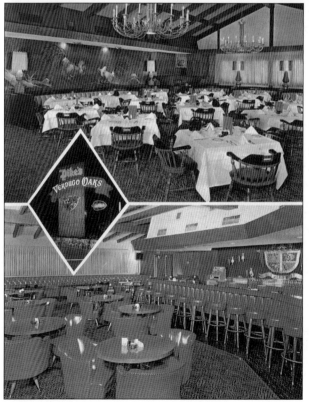

The shopping area along Kenneth Road between Grandview and Sonora Avenues was developed in the early 1920s. By the late 1960s, the area became known as Kenneth Village. This late-1950s view shows drugstores on each corner. (Courtesy of the Special Collections Room, Glendale Public Library.)

Pikes Verdugo Oaks Restaurant and Banquet facility, at the intersection of Verdugo Road and Canada Boulevard, was the pride of the community since its opening in 1957. Locally owned and operated by Jack and Mary Pike, it was "Glendale's largest and finest restaurant" until business slowed, forcing closure in the 1980s. The elegant Versailles banquet room (not pictured) hosted many community events. (Courtesy of Elmer Art.)

Three

No Longer Isolated
1960–1970

Glendale had a population of 119,422 in 1960 and grew 1.1 percent by the end of the decade. During the 1960s and beyond, Glendale was successful at avoiding governmental programs and policies of the era to reduce poverty and address social issues. Sweeping social changes across the country meant that Glendale could no longer hold onto its small-town feel. The community wished to remain independent of larger government mandates because it was a community that would take care of its own problems.

The freeway system, which was supported as a means to bring in more business, caused the city to become a part of the larger metropolis. The construction of the Crosstown Freeway, later known as the Ventura Freeway, was started in Glendale in 1967 and completed in 1969. In 1963, the planned Foothill Freeway portion through the Crescenta Valley had five alternate routes that crossed the valley from north to south. Extensive debate occurred over what route would be built. New freeways allowed Glendale residents to shop outside the city. The loss of shoppers to the city, combined with low population growth, resulted in a decline in retail sales and less revenue needed to fund a police force that brought a low crime rate and pride to the community.

Los Angeles County was attracting more and more newcomers as its economy strengthened. A large percentage of Glendale residents were employed in manufacturing throughout the area. Overbuilding of apartments in the early 1960s lead to a building slump that lasted the rest of the decade. Aging buildings on Brand Boulevard were being modernized to give them a new sleek look, but by the late 1960s the landscape of the city was changing. By the end of the decade, the planning director advocated drastic measures to reverse the decline through the use of redevelopment. A series of studies showed that Glendale's decline was worsening, with a loss of retail sales to neighboring areas with modern shopping facilities.

In 1966, the Glendale Fashion Center opened with 3 principal stores, 20 specialty shops, 2 restaurants, and a parking structure. In 1961, an impressive new First Methodist church was built and renamed the First United Methodist Church. The larger civil rights movement led to the creation of the local Human Relations Council in 1963. In 1969, the new Glendale and Hoover High Schools were finished.

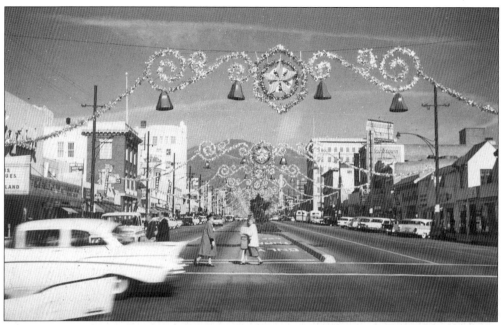

Christmas decorations along Brand Boulevard were hung from poles and ran from Colorado Boulevard to Doran Street. The annual tradition was phased out as overhead wires were placed underground. This 1961 image shows the tunnel looking north on Brand Boulevard from Harvard Street. The Capital Theatre is pictured at left. (Courtesy of the Special Collections Room, Glendale Public Library.)

Orange Street was widened, as pictured in this 1960 photograph from the intersection with Wilson Avenue, looking north. At right is the Evergreen Produce stand, and Glendale Federal is pictured in the distance. (Courtesy of the Special Collections Room, Glendale Public Library.)

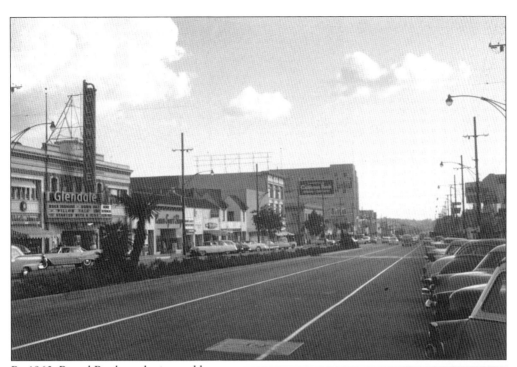

By 1960, Brand Boulevard, pictured here looking south toward Colorado Street, had a landscaped median that softened the wide boulevard. The Glendale Theatre is pictured at left. (Courtesy of the Special Collections Room, Glendale Public Library.)

The Glendale Federal Savings and Loan flagship headquarters is pictured here in 1965 at the corner of Brand Boulevard and Lexington Drive. The ultra-modern, nine-story building constructed in 1959 was the initiative of Glendale Federal founder Joe Hoeft to bring his once small savings and loan institution into the modern age of finance. By 1974, Glendale Federal had the largest system of branch offices of any federal savings and loan organization in the nation with over 30 branch offices. Joe Hoeft and Glendale Federal were strong supporters of the Glendale Symphony and helped it flourish in the 1960s and 1970s. The building and the Glendale Federal institution assisted in making Glendale a recognizable banking center. (Courtesy of the Special Collections Room, Glendale Public Library.)

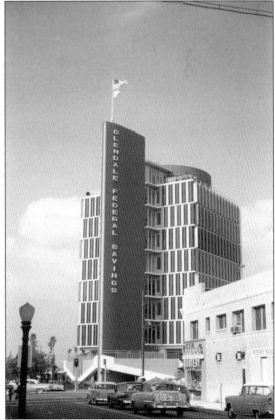

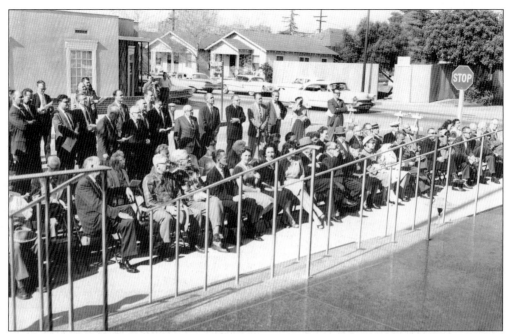

A new, $1 million Glendale Police headquarters was dedicated on November 23, 1960, as pictured here. The modern building replaced a 36-year-old facility on Howard Street behind city hall. The new jail had the capacity to hold 100 prisoners. (Courtesy of the Special Collections Room, Glendale Public Library.)

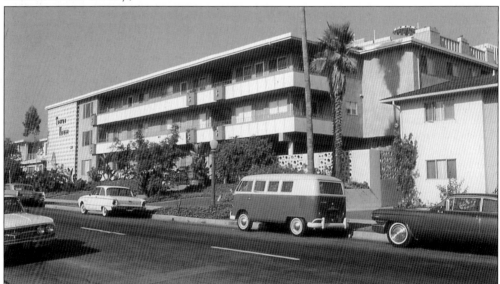

The early 1960s saw an economic boom in Southern California. As a result, Glendale experienced a dramatic increase in apartment construction. Many of the developers from out of town saw opportunity in Glendale. Some landowners were local and sold their property and moved out of town, especially to newer areas within Orange County. Some apartments in the early 1960s were built in the handsome modern style of the time, like this three-story building pictured in 1966, and others were built with little thought to design, intending to generate a rapid economic return. (Courtesy of the Special Collections Room, Glendale Public Library.)

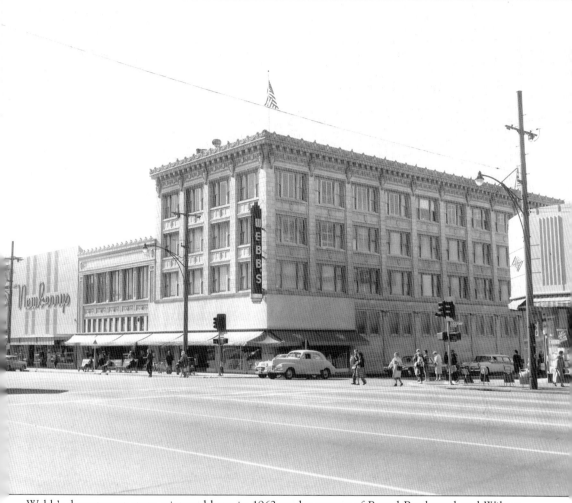

Webb's department store, pictured here in 1962 at the corner of Brand Boulevard and Wilson Avenue, was the cornerstone of shopping for the community. It was locally owned and operated and expanded to several other buildings nearby. The store offered high-quality clothing and household items. Harry S. Webb came to Glendale in 1916 from Chicago, convinced that California offered a great opportunity for a department-store business. His first Webb's store was near the corner of Brand Boulevard and Broadway. (Courtesy of the Special Collections Room, Glendale Public Library.)

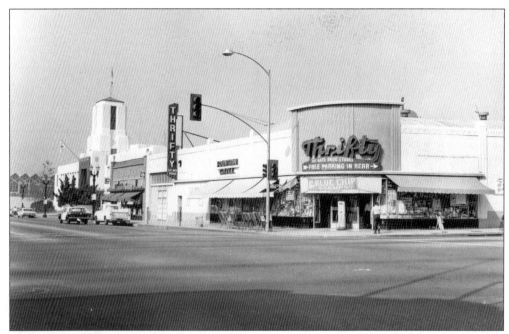

Pictured here, between city hall and the Thrifty's drugstore, is the Glendale Pharmacy that opened in 1905 as the community's first drugstore. It relocated to this site in 1933. Both Thrifty's and the Glendale Pharmacy were demolished in 1964 for the new municipal services building. (Courtesy of the Special Collections Room, Glendale Public Library.)

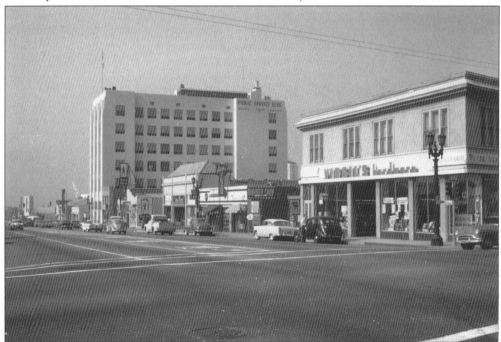

The southwest corner of Glendale Avenue and Wilson Avenue was the location of the first Virgil's hardware store, pictured here in 1960. The city's public service building stands prominently in the background. (Courtesy of the Special Collections Room, Glendale Public Library.)

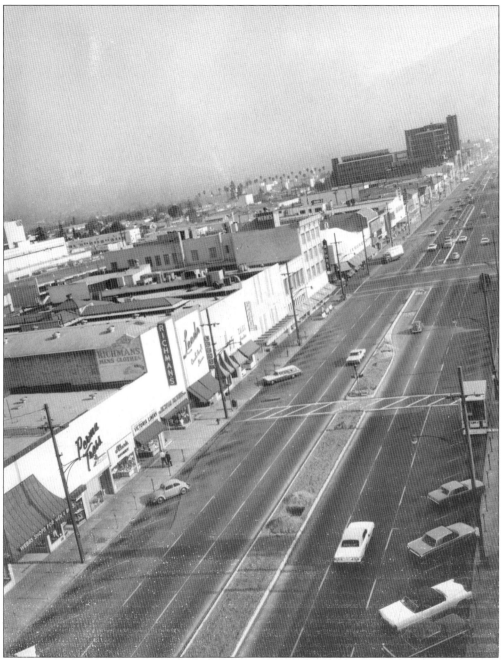

By the late 1960s, the once-grand Brand Boulevard shopping district began to lose patrons, as pictured here in 1966. The new Southern California freeway system meant that Glendale residents could shop outside the city at newer stores. It was the year that nearby Fashion Center opened, but many Glendale residents were moving out of the city and heading to newly developing communities in Southern California. Many of the old buildings underwent facade changes to modernize their appearances. (Courtesy of the Special Collections Room, Glendale Public Library.)

Glendale in the 1950s and 1960s held many beauty pageants, often associated with community events and celebrations. In this 1960 photograph, beauty contestants pose at the Verdugo Swim Stadium across from Glendale College. (Courtesy of the Special Collections Room, Glendale Public Library.)

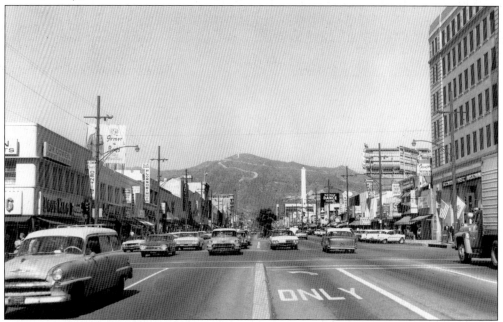

The picturesque Verdugo Mountains provides a natural setting against the urban streetscape of Brand Boulevard in this 1967 photograph looking north from Broadway. (Courtesy of the Special Collections Room, Glendale Public Library.)

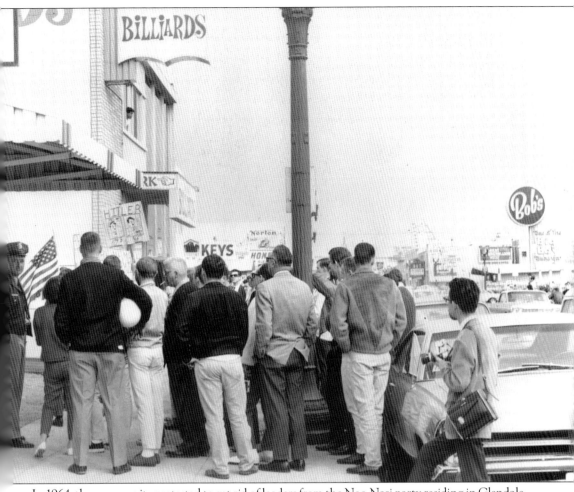

In 1964, the community protested to get rid of leaders from the Neo-Nazi party residing in Glendale. The Glendale police and the community were successful in finding a way to drive the group out of town. These images were all over local newspapers and helped create a reputation that Glendale was a racist community. Up until recently, the city has suffered from a nondescript, generic reputation as a racist city, which is somewhat deserving and somewhat myth, but mostly these are legends lost in translation and stories overblown by the media. Tales of a law and street signs that prohibited African Americans from being in the city after dark were pervasive but unfounded. Past research by various individuals on the subject revealed no evidence that a curfew, real or accepted, existed. Barbara Boyd, a well-known local historian, reported that this myth started when people regularly saw a group of African American female housekeepers waiting for the last train out of town just before dark as they headed home. Glendale has attracted various extremist groups that are drawn from the city's reputation as an all-white community, but these groups did not receive the welcome they expected, and media attention given to efforts fueled more bad press for the city. The real racism started when Glendale prided itself as the fastest-growing city in America and increasing residential subdivisions prohibited real estate sales to African Americans. This resulted in a Glendale population that had an abnormally low African American population. Housing discrimination towards African Americans trying to rent in Glendale continued in the 1980s and 1990s. Not until the year 2000 has Glendale ever had a sizable African American population, but it still remains low at only 1.3 percent. (Courtesy of the Special Collections Room, Glendale Public Library.)

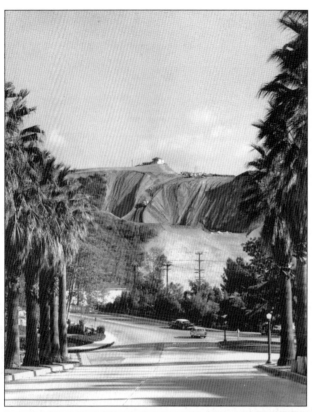

Grading for a new housing development is pictured here in 1963 from the intersection of Royal Boulevard and Mountain Street. (Courtesy of the Special Collections Room, Glendale Public Library.)

Since the mid-1950s, the city government had been planning to develop a government center around the site of the original city hall, built in 1912, to create a government campus environment. In 1966, this futuristic building was constructed to convey the modernity of city government and to shed its former image as a sleepy bedroom community. The floating municipal services building stood 14 feet above the street, providing multiple government services in an efficient, single facility. (Courtesy of the Special Collections Room, Glendale Public Library.)

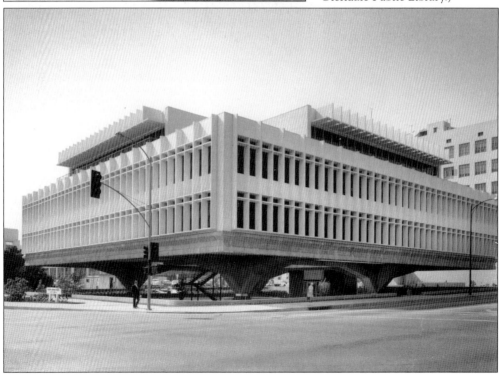

The new and modern Crawford grocery store at the northeast corner of Central Avenue and Stocker Street received one of the 1968 awards for outstanding contribution to the beauty of the city during the city's first beautification week in its "war on ugliness." In 1986, this supermarket became Ralph's market. (Courtesy of the Special Collections Room, Glendale Public Library.)

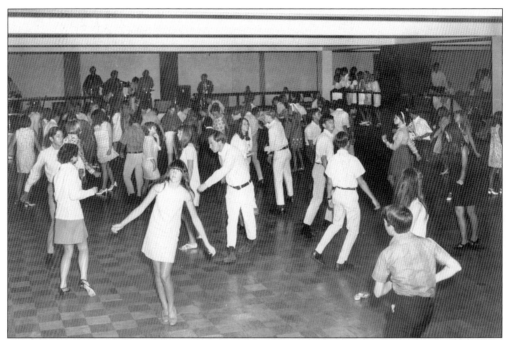

Since it opened, the Glendale Civic Auditorium has held public dances throughout the years. While big bands played in the late 1930s and 1940s for adults upstairs, teen bands in the 1960s played for school kids on the basement level. (Courtesy of the Special Collections Room, Glendale Public Library.)

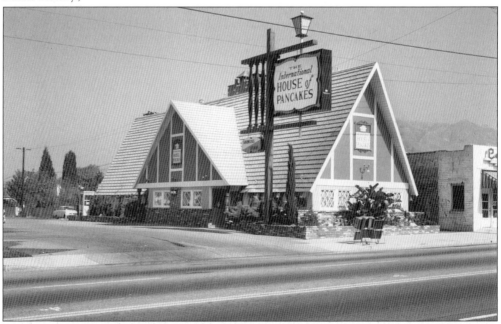

The International House of Pancakes (IHOP) opened one of its first restaurants in the city at Glendale Plaza, pictured here in 1964. In the 1990s, the IHOP corporation moved its headquarters to Glendale in a new high-rise office on Brand Boulevard. (Courtesy of the Special Collections Room, Glendale Public Library.)

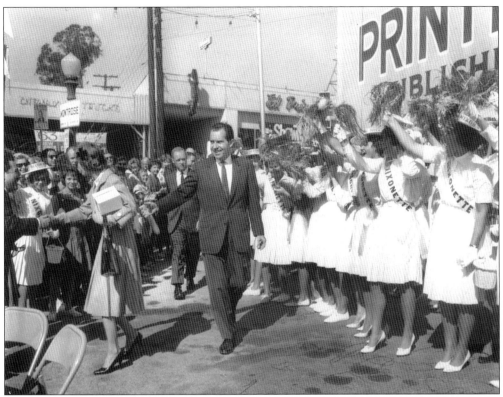

Candidate Richard Nixon and his wife Pat campaign in Montrose in 1962 as he runs for the governor of California. (Courtesy of the Special Collections Room, Glendale Public Library.)

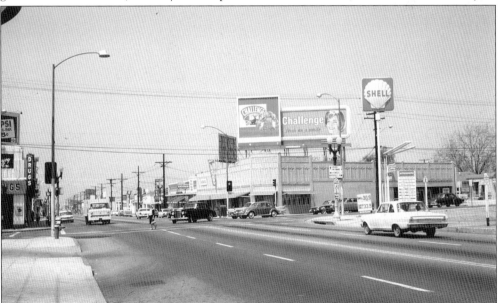

Like other Glendale commercial corners, the intersection of Colorado Boulevard and Verdugo Road had a drugstore on the southwest corner, pictured here in 1964. (Courtesy of the Special Collections Room, Glendale Public Library.)

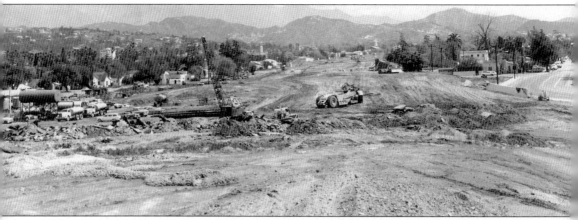

The Crosstown Freeway is under construction in this photograph taken on April 6, 1967, looking east from San Fernando Road. The recently completed Verdugo Towers condominium high-rise building is faintly visible at left. (Courtesy of the Special Collections Room, Glendale Public Library.)

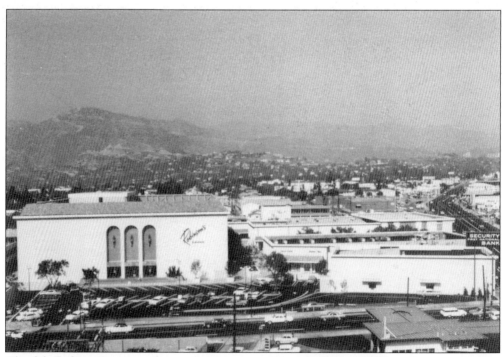

Glendale Fashion Center, at the northwest corner of the Glendale and Wilson Avenues, features the Robinson's department store, pictured facing Wilson Avenue in this c. 1967 photograph. The Security First National Bank on the corner replaced Glendale's first bank, built in 1905 on this same corner. (Courtesy of the Special Collections Room, Glendale Public Library.)

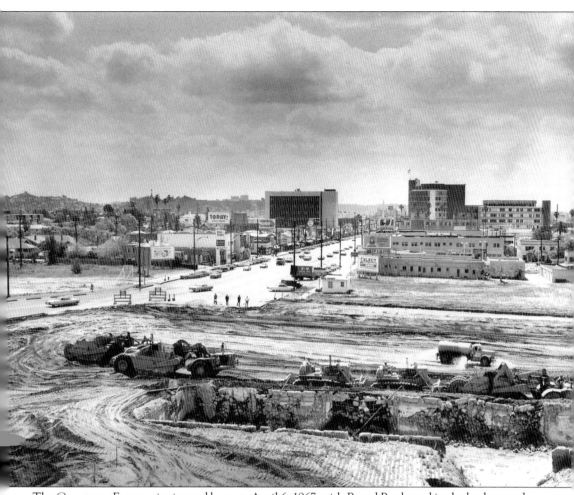

The Crosstown Freeway is pictured here on April 6, 1967, with Brand Boulevard in the background, the Valley National Bank (no longer existing) at left, and Glendale Federal (currently found to be historically significant) at right. The old concrete underground wall pictured in the foreground is from a former building demolished for freeway construction. (Courtesy of the Special Collections Room, Glendale Public Library.)

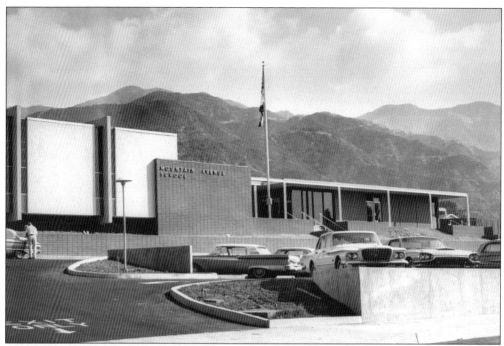

The new modern Mountain Avenue School opened in 1967 on the former homesite of the William Bishop family of the Crescenta Valley that once overlooked the whole region. (Courtesy of the Special Collections Room, Glendale Public Library.)

Newly constructed Rosemont Junior High School, pictured in 1961, was designed in a classic modern style with clean long lines providing a contrast against the Verdugo Mountains in the background. (Courtesy of the Special Collections Room, Glendale Public Library.)

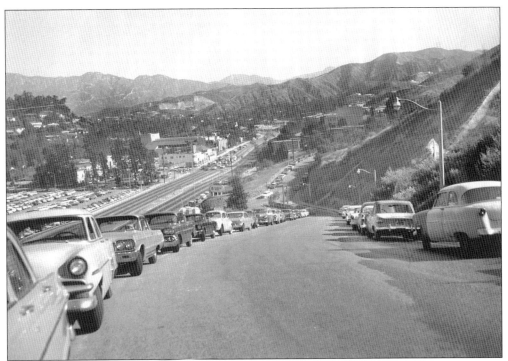

The Glendale College parking shortage is well documented in this 1965 photograph. (Courtesy of the Special Collections Room, Glendale Public Library.)

The Doctor's House is pictured on its original site at Belmont Street and Wilson Avenue in this 1967 photograph. (Courtesy of the Special Collections Room, Glendale Public Library.)

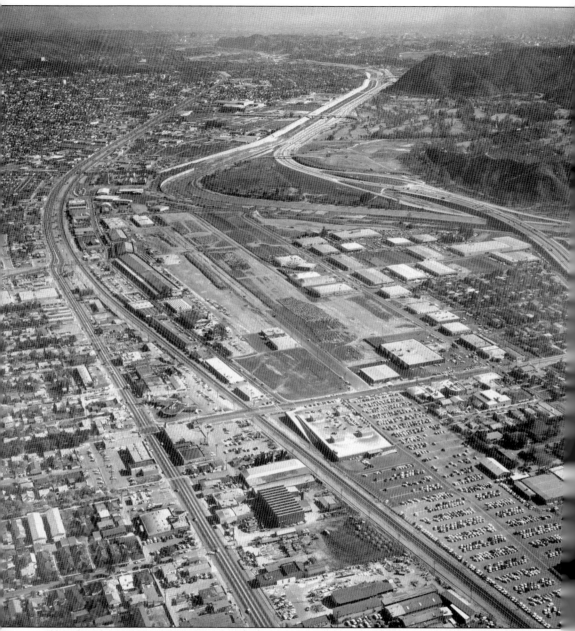

Grand Central Industrial Park provided clean industrial facilities on the former site of the Grand Central Airport and became a model for planned light-industrial land use. The Golden State Freeway and the Los Angeles River are in the background in this 1961 photograph. (Courtesy of the Special Collections Room, Glendale Public Library.)

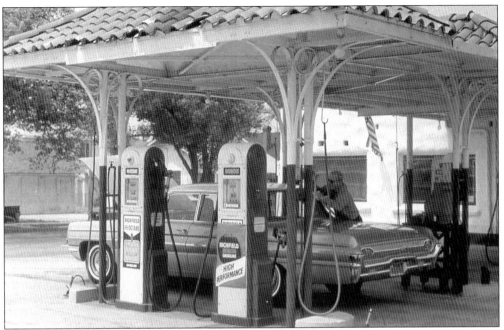

This Spanish-style, old-fashioned gas station at the corner of Stocker Street and Central Avenue was in full operation when this 1964 photograph was taken. (Courtesy of the Special Collections Room, Glendale Public Library.)

A construction worker finalizes work at the Glendale Fashion Center just before the grand opening in 1966. (Courtesy of the Special Collections Room, Glendale Public Library.)

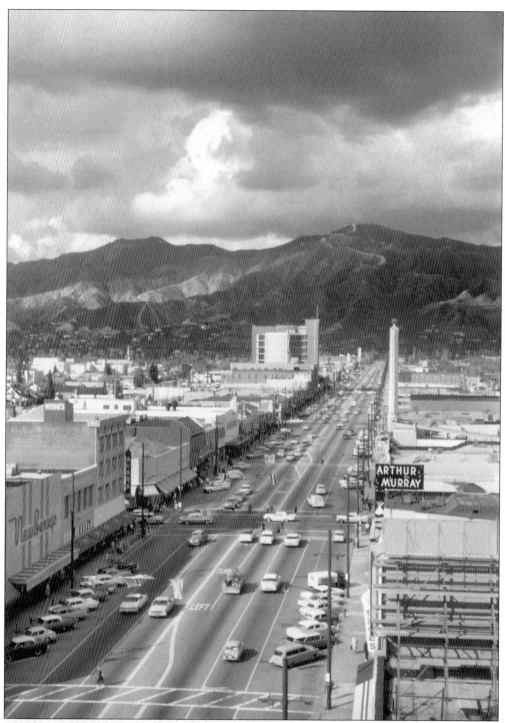

This 1962 photograph looks north over the Glendale skyline from the top of the six-story Security Bank building at Broadway. The Glendale Federal building and the Alex Theatre spire are the only tall structures along the boulevard. (Courtesy of the Special Collections Room, Glendale Public Library.)

The Verdugo Towers was the city's first high-rise residential building, which was constructed in 1966 at Brand Boulevard and Stocker Street. The units were sold as condominiums. The much smaller Casa Verdugo Branch Library and Fire Station are at left. (Courtesy of the Special Collections Room, Glendale Public Library.)

A new fountain was installed near Brand and Glenoaks Boulevards to help beautify the city. (Courtesy of the Special Collections Room, Glendale Public Library.)

One of the parks and recreation division's most ambitious projects was creating a recreation area from the huge "cut and fill" land reclamation project at Scholl Canyon, which included the ball field in this 1969 photograph. (Courtesy of the Special Collections Room, Glendale Public Library.)

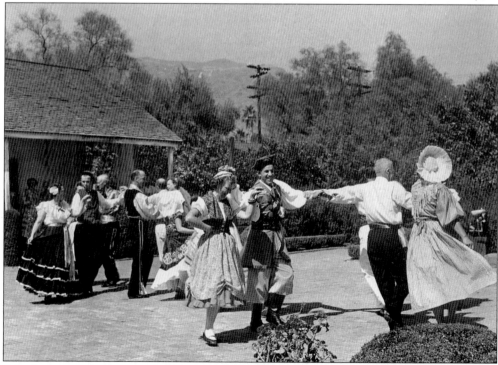

Folk dancing activities provided by the parks and recreation division were offered at the Casa Adobe de San Rafael. (Courtesy of the Special Collections Room, Glendale Public Library.)

Housing construction is active in the Greenbrier subdivision in this 1968 photograph. (Courtesy of the Special Collections Room, Glendale Public Library.)

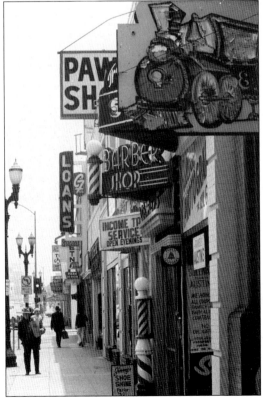

A proliferation of business signage in the late 1960s caused concern that the city's image as a clean community was waning. A new signage ordinance, adopted in the early 1970s, forced businesses to clean up their look. (Courtesy of the Special Collections Room, Glendale Public Library.)

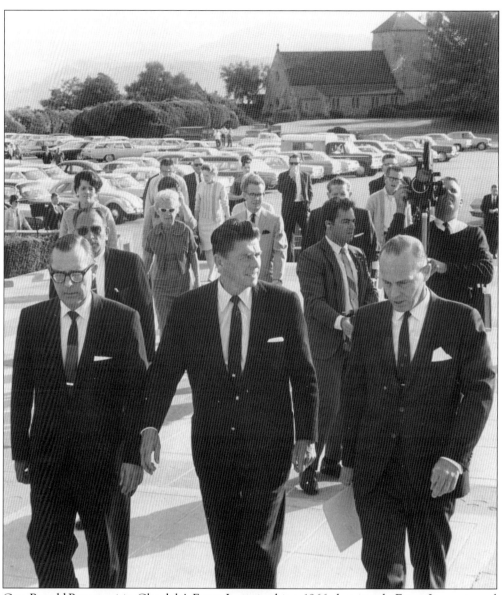

Gov. Ronald Reagan visits Glendale's Forest Lawn in this c. 1966 photograph. Forest Lawn general manager Fredrick Llewellyn is standing to Reagan's right. (Courtesy of the Special Collections Room, Glendale Public Library.)

Four

FREEWAYS TO EVERYWHERE
1970–1980

Glendale's population was 132,719 in 1970 and grew by 4.8 percent by the end of the decade. The city began to look worn out. Businesses reduced their investment, and decline occurred rapidly. Old and cluttered signage gave the city a bad feel. The city's redevelopment agency was formed in 1971 to reverse the downward trend, and the community underwent an internal struggle. Community leaders knew that redevelopment was the best means to reverse the economic decline, but the idea of taking control of private lands was not popular with the community's beliefs. Residents along the west side of Central Avenue demanded to be removed from the boundary that encompassed much of the city's central business district.

By 1972, with the completion of the Foothill Freeway in La Crescenta, Glendale was surrounded by freeways that could get people everywhere. Glendale became known as the city within the "Golden Triangle," formed by the Golden State Freeway on the west, the Glendale Freeway on the east, and the Foothill Freeway along the north. The first redevelopment project was the Glendale Galleria that started in 1974 and was completed in 1976. The Galleria was so successful that a second phase to extend the mall to Brand Boulevard and a third phase to include a hotel and mixed uses were planned immediately. New office buildings were being built near the recently completed Ventura Freeway. Growth in single-family units stabilized while higher growth in multifamily units occurred. At the end of the decade, the city saw a large condo conversion of its apartments. In 1977, the "financial square" above the Ventura Freeway was planned and in 1979 the Allstate Insurance Company moved its headquarters to a new building on Brand Boulevard. In 1970, Glendale College became Glendale Community College with its own community college district. Verdugo Hills Hospital was built on the city's northern edge in 1972. The new Central Library opened in 1973. The Grayson Power Plant opened in 1977, named after Loren Grayson, the chief engineer and general manager of the water and electric division since 1951.

New population groups moved into the city. Latinos, mostly Mexican American and Cuban, came in the early 1970s. Many organizations and churches merged in this period. The 1970s also saw new ethnic churches making Glendale their home, including St. Mary's Armenian Church on Chevy Chase Drive and the Filipino Seventh-day Adventist Church.

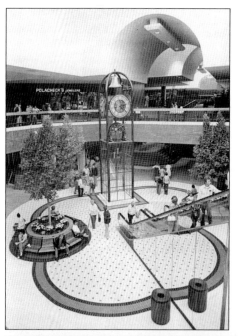

The Glendale Galleria brought new life to shopping in Glendale. Built between 1974 and 1976, it provided four department stores and a multitude of specialty shops in a modern indoor environment and became one of the nation's successful malls, gaining more success than the city originally thought when it was approved in the early 1970s. Some displaced businesses and existing shops on Brand Boulevard relocated into the mall, while others closed. (Courtesy of the Special Collections Room, Glendale Public Library.)

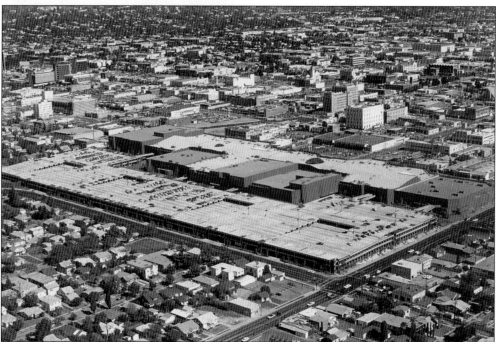

The expansive Glendale Galleria by Donahue Schriber of Irvine displaced a large swatch of residents and business. This 1978 photograph shows the physical impact on the center of town. Its success lead to more redevelopment of Glendale and booming office development immediately followed, to be clustered around the 134 Freeway and the existing Glendale Federal headquarter office tower. Soon after the Galleria opened, a Galleria II and Galleria III were planned. The Galleria would mark the center of retail for Glendale into the year 2000. (Courtesy of the Special Collections Room, Glendale Public Library.)

The 1971 Sylmar earthquake damaged many unreinforced buildings in Glendale, including the First Methodist Church on Wilson Avenue and Kenwood Street. (Courtesy of the Special Collections Room, Glendale Public Library.)

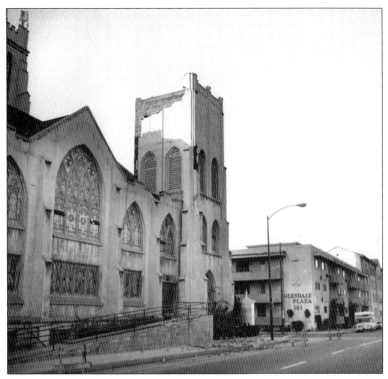

The earthquake also made the landmark clock tower of the Presbyterian Church unstable and caused the church to rebuild. (Courtesy of the Special Collections Room, Glendale Public Library.)

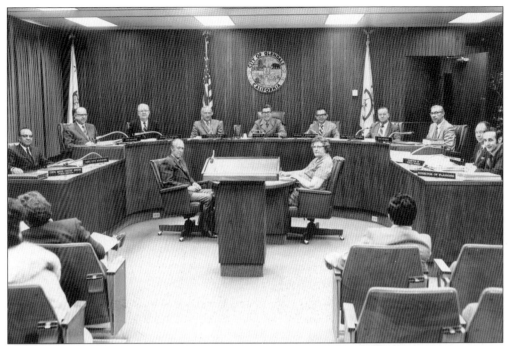

The 1971 Glendale City Council was faced with a rapidly changing Glendale in modern times. Seated, from left to right, are city manager C. E. Perkins, councilman Allen Watson, councilman Vern Allen, mayor James Perkins, councilman Warren Haverkamp, and councilman Howard Peters. In 1972, city manager C. E. Perkins spoke to the Glendale Rotary Club about "future shock" and its premature arrival. He claimed that Glendale could no longer wall itself in from a rapidly changing world. (Courtesy of the Special Collections Room, Glendale Public Library.)

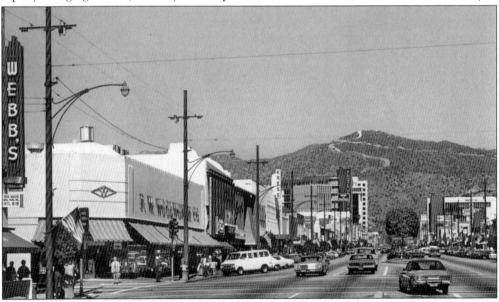

This postcard image of downtown Glendale around 1974 shows the business district and the Verdugo Mountains as the backdrop. Woolworths is pictured at left. (Courtesy of the Special Collections Room, Glendale Public Library.)

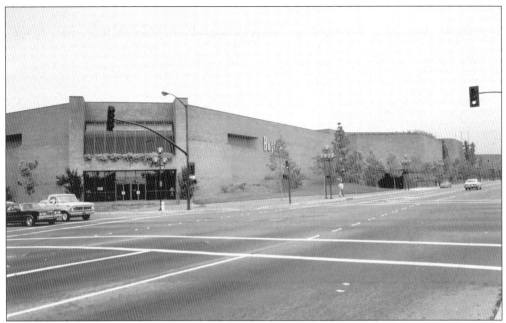

The Buffin's department store was among the original four department stores in the Glendale Galleria in this 1978 photograph, but closed and was demolished and replaced by a new building housing the Robinsons-May department store. (Courtesy of the Special Collections Room, Glendale Public Library.)

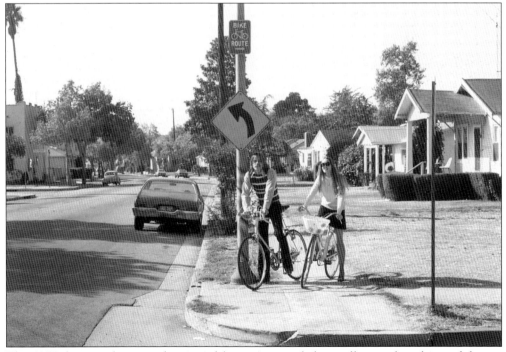

This 1975 photograph was used as part of the city's general plan to illustrate bicycling and the use of city bike paths as an alternative mode of transportation and a recreational activity. (Courtesy of the Special Collections Room, Glendale Public Library.)

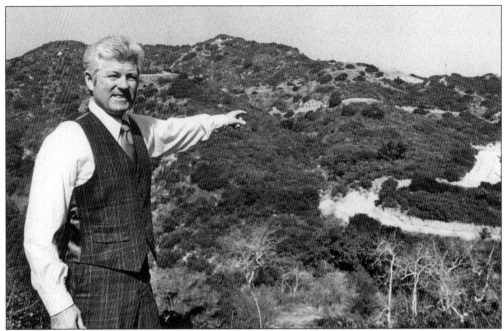

Mayor Robert Garcin points to Henderson Canyon in 1979 to show the location of possible future development. (Courtesy of the Special Collections Room, Glendale Public Library.)

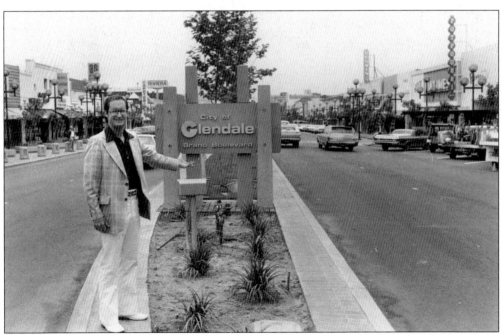

Glendale's Brand Boulevard is displayed proudly for this promotional photograph leading up to the Days of the Verdugos activities in 1979. (Courtesy of the Special Collections Room, Glendale Public Library.)

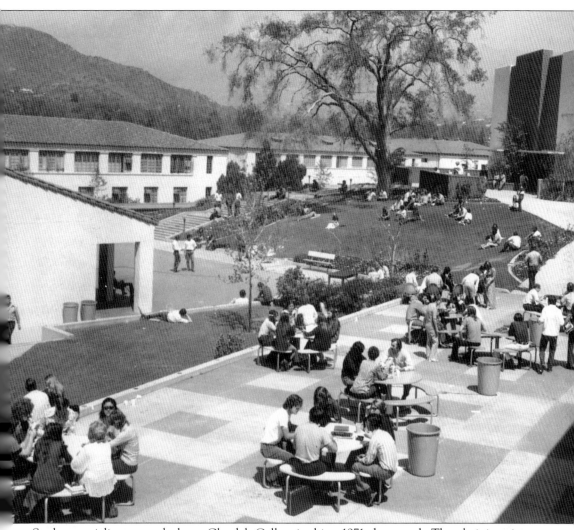

Students socialize, eat, and relax at Glendale College in this c. 1971 photograph. The administration building is at left, and the library is in the center. (Courtesy of the Special Collections Room, Glendale Public Library.)

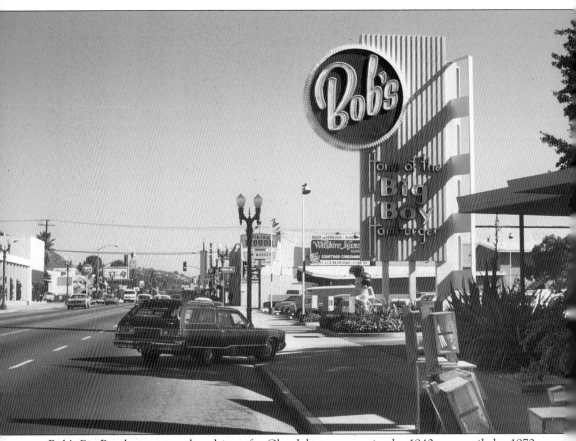

Bob's Big Boy became a cultural icon for Glendale teenagers in the 1940s up until the 1970s. After the widely popular Glendale and Hoover High School football games, lines of cars filled with local students would meet and eat at Bob's Big Boy on Colorado Street. By the time this photograph was taken in 1975, Bob Wian had sold his Bob's Big Boy restaurant business to the Marriott Corporation with 600 franchises throughout America. (Courtesy of the Special Collections Room, Glendale Public Library.)

Wilson Junior High School, located near Verdugo and Monterey Roads, is pictured here in 1972. (Courtesy of the Special Collections Room, Glendale Public Library.)

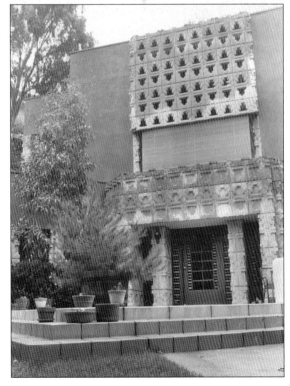

The Derby House in Glendale's Chevy Chase canyon area in this 1972 photograph was designed, and built in 1926, by Lloyd Wright, son and student of the famous architect Frank Lloyd Wright. It was his modern interpretation of pre-Columbian or Mayan architecture. As of 2000, the Derby House was Glendale's only home listed on the National Register of Historic Places. (Courtesy of the Special Collections Room, Glendale Public Library.)

The 1974 opening of the Japanese Tea House in Brand Park included traditional Japanese ceremonies by visitors from Glendale's sister city Higashiosaka, Japan. (Courtesy of the Special Collections Room, Glendale Public Library.)

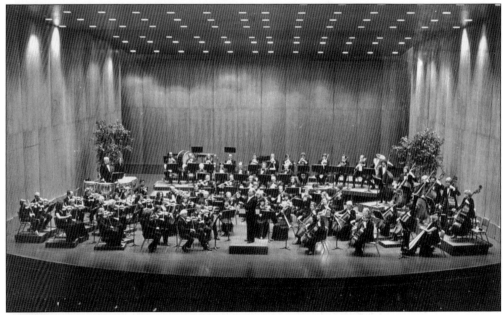

During much of Glendale's modern history, the Glendale Symphony represented its cultural heritage. Largely supported by private donors, the Glendale Symphony played in the Dorothy Chandler Pavilion because attendance was too high to be accomodated by any venue in Glendale. This c. 1979 photograph shows the Glendale Symphony and its musical director, Carmen Dragon, playing at the Dorothy Chandler in downtown Los Angeles. (Courtesy of the Special Collections Room, Glendale Public Library.)

In 1946, Mr. and Mrs. Bashor from Los Angeles purchased the old Verdugo Adobe from the Newport Development Company with the intention of saving the old home of Teodoro Verdugo and making it their second home. When Mr. Bashor died, Mrs. Bashor moved in the adobe full-time and decorated it in a fantasy Mexican look in this 1975 photograph. Before she died, she conveyed the property to the city, which acquired it in 1989. The Verdugo Adobe is on the National Register of Historic Places. (Courtesy of the Special Collections Room, Glendale Public Library.)

In 1969, the city constructed a new addition to Brand Library to house an art gallery and a recital hall. This photograph shows an art show in 1971. (Courtesy of the Special Collections Room, Glendale Public Library.)

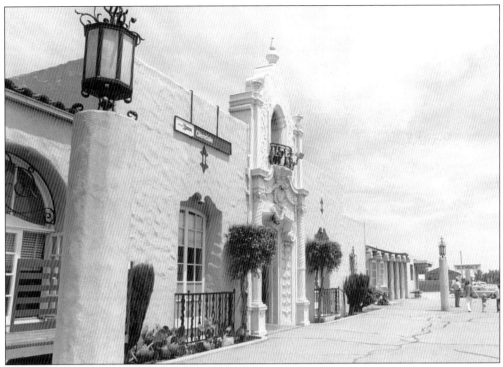

The Southern Pacific Depot built in 1923 served as Glendale's stop for heavy-rail passenger transportation in Glendale. In the 1990s, the depot was to become the focal point for regional transportation with commuter-rail transportation by the Metrolink system. Cooperative efforts between the city, the federal government, and regional transportation bodies transformed the depot into the Glendale Transportation Center by the year 2000. (Courtesy of the Special Collections Room, Glendale Public Library.)

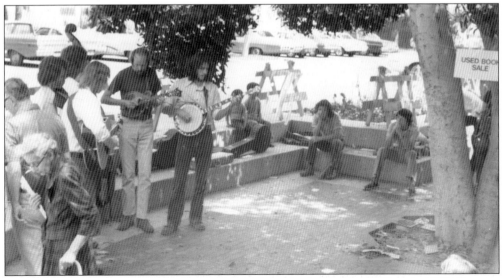

Entertainment was provided at the Central Library's first book sale, pictured here in 1975. The new large Central Library was completed just two years earlier and was four and one-half times larger than the old Central Library. (Courtesy of the Special Collections Room, Glendale Public Library.)

After the 1971 earthquake, the Presbyterian Church rebuilt its place of worship in 1974, retaining the old basement. In 2000, the Arabic Community Christian Church offered services spoken in Arabic, having moved to the Presbyterian from a smaller Glendale location. By 2000, only 1.5 percent of the Glendale population was of Arabic ancestry, but the church was attracted to Glendale because of a large Christian Armenian population from Arabic-speaking countries. (Courtesy of the Special Collections Room, Glendale Public Library.)

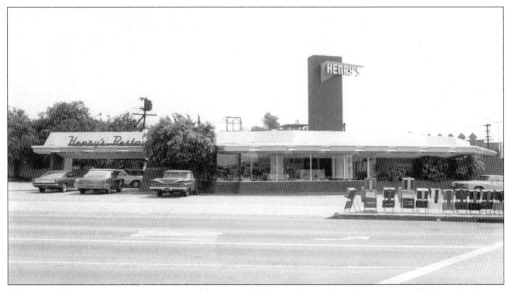

The new Henry's restaurant, pictured here in 1977, was located at the corner of Colorado Street and Glendale Avenue. (Courtesy of the Special Collections Room, Glendale Public Library.)

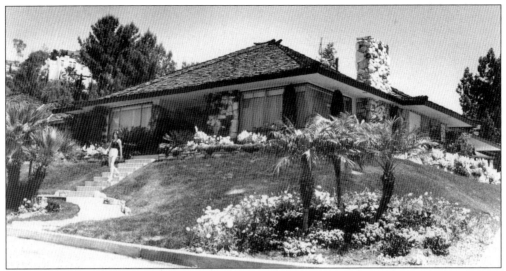

The Fiss House, pictured in 1979, is typical of the Glendale homes built in this period, combining toned down modern elements with traditional and ranch style elements, creating a comfortable and relaxed home. Also important was the landscaping design based on the Southern California climate and incorporating drought-tolerant plants. (Courtesy of the Special Collections Room, Glendale Public Library.)

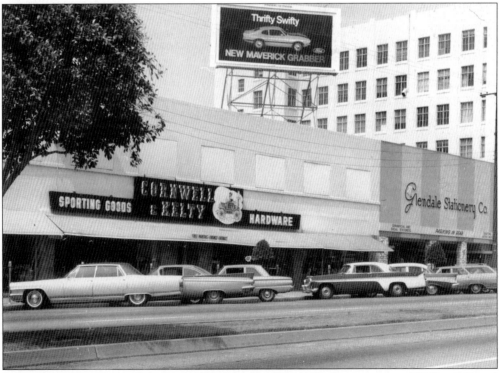

Pictured in 1972, Cornwell and Kelty Sporting Goods and Hardware store at 115 South Brand Boulevard is one of Glendale's oldest stores. It opened in 1911, owned and operated by Albert Cornwell and his son Glenn, who have been active in Glendale community and business organizations for decades. (Courtesy of the Special Collections Room, Glendale Public Library.)

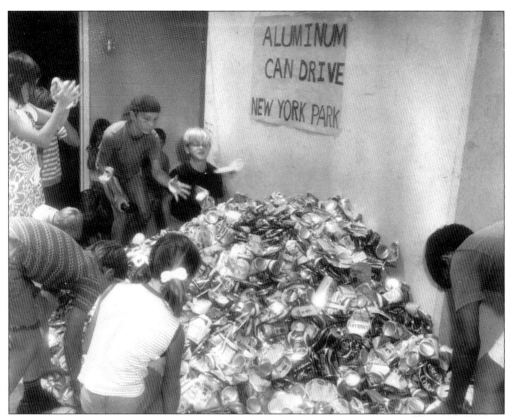

La Crescenta kids gather and crush cans at the aluminum can drive at New York Park in 1970. (Courtesy of the Special Collections Room, Glendale Public Library.)

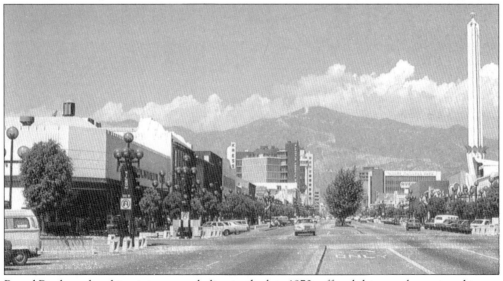

Brand Boulevard and its picturesque skyline in the late 1970s offered this popular postcard image of the city. Brand Boulevard is pictured here in 1978 with a new streetscape, wide sidewalks, transit stops, and light fixtures provided by the Glendale Redevelopment Agency. (Courtesy of the Special Collections Room, Glendale Public Library.)

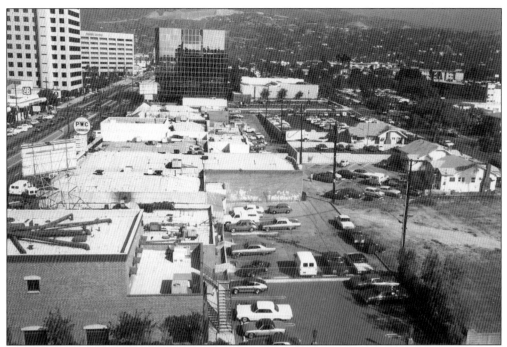

This photograph of the east side of Brand Boulevard was taken in the late 1970s and shows a large swatch of low-rise buildings redeveloped with high-rise office towers constructed in the 1980s and 1990s. The former Allstate Savings bank, part of the financial square, is in the background at left, just north of the 134 Ventura Freeway. (Courtesy of the Special Collections Room, Glendale Public Library.)

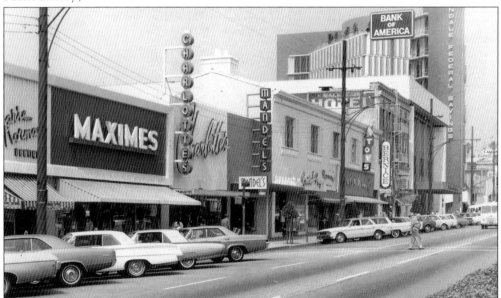

By the late 1970s, Brand Boulevard had a mix of old and new buildings that redevelopment set out to transform by creating a financial section at the top around the Ventura Freeway, a retail center at the bottom with the Galleria mall, and the low-scale shops in between in this photograph. (Courtesy of the Special Collections Room, Glendale Public Library.)

Since the 1930s, Woolworths was a popular store with its convenient lunch counter located at 201 North Brand at the corner of Wilson Avenue, pictured here in 1974. (Courtesy of the Special Collections Room, Glendale Public Library.)

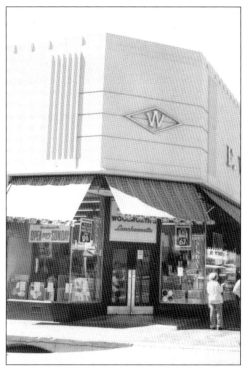

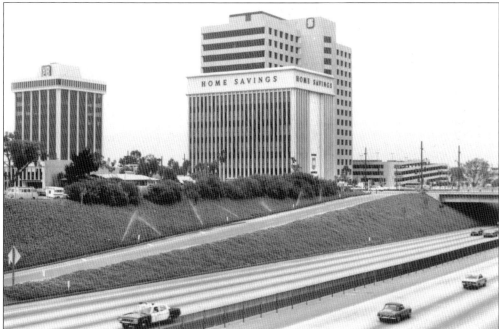

Glendale's first high-rise office district was around Glendale Federal, but with the new freeway system, banks in the 1970s and office headquarters in the 1980s clustered around the 134 Ventura Freeway in this 1974 photograph. The Home Savings building, in the center, was built in 1969 and is the city's second-oldest commercial high-rise building. (Courtesy of the Special Collections Room, Glendale Public Library.)

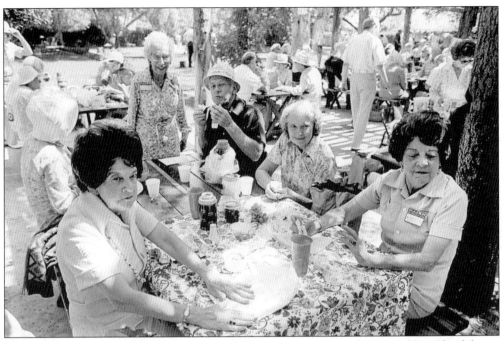

A tradition almost as old as Glendale itself is the annual Labor Day Old Timers Picnic at the Casa Adobe de San Rafael. This group of longtime Glendale residents gathers at the 1979 picnic. (Courtesy of the Special Collections Room, Glendale Public Library.)

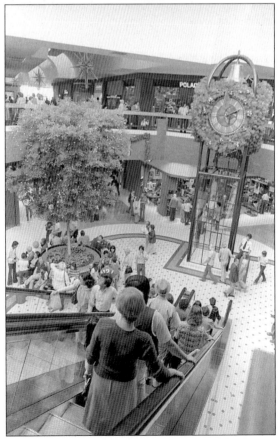

The Galleria mall drew people from all over the region to shop in Glendale, pictured here in 1979. By the late 1980s, the Galleria was reported to be the fifth-largest mall in the country. (Courtesy of the Special Collections Room, Glendale Public Library.)

Student dances turned to disco as pictured in this dance contest at Wilson Junior High School in 1979. (Courtesy of the Special Collections Room, Glendale Public Library.)

Young people display the Glendale cheer at Verdugo Park in 1979. The annual Days of the Verdugos festivities include a carnival in Verdugo Park. By the early 1970s, this annual Glendale tradition grew so large that a special association was set up to organize the multitude of events. (Courtesy of the Special Collections Room, Glendale Public Library.)

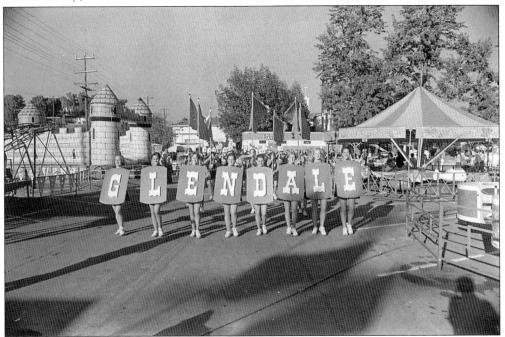

Miss Glendale posed for this photograph at the 1979 Days of the Verdugos festival. In addition to a Miss Glendale pageant, the festival included an art show, a pancake breakfast, picnics, and, most importantly, a parade down Brand Boulevard. (Courtesy of the Special Collections Room, Glendale Public Library.)

Five

THE JEWEL
IS REDISCOVERED
1980–1990

Glendale had a population of 139,060 in 1980, increasing 29.5 percent by the end of the decade. Nearby Pasadena had the Rose Bowl and Burbank had its studios, and Glendale felt it needed an identity. Redevelopment in the 1980s, fueled by revenues from the Galleria, now focused on attracting corporate headquarters. The city hired a young woman with a background in law and finance as redevelopment's executive director. Businesses were moving out of downtown Los Angeles wanting less congestion, cheaper rents, and easy accessibility to workers. Glendale positioned itself as a great alterative with a freeway that was close, a good workforce for miles around, and a stable and welcoming government. The headquarters for Glendale Federal and Fidelity Federal were already dominating features on Brand Boulevard. Many small businesses suffered from being displaced by redevelopment projects. It was reported that eminent domain was used 14 times in 1987. The Galleria expanded in 1983, adding two new department stores for a total of six. Then the search for a major hotel started.

Larry Zarian, developer and long-time Glendale resident and community leader, was elected to the city council in 1983 and became Glendale mayor twice. Talk of a cultural arts center began in 1984, and leaders were looking to see if the Alex Theatre would be adequate or if a new performing arts center could be built. In 1989, the Korean School of Southern California moved to the Crescenta Valley. Ethnic restaurants started to emerge into an industry dominated by American-style restaurants. Many of the ethnic eateries from the early 1980s were Chinese, Vietnamese, Japanese, and Thai. Only one or two expensive restaurants were found in Glendale. Ethnic issues were all over the newspapers in the city as they were across the state and county. In 1986, the old Glendale Human Relations Council was reactivated. The boom in apartment construction occurred following the early 1980s office projects and the community questioned what was going on. By the late 1980s, residents were frustrated with increasing traffic and an antigrowth movement started. A land-use and zoning consistency program was adopted by the city council, which recognized that the city's existing zoning allowed for more residential units than could be supported by the city's infrastructure.

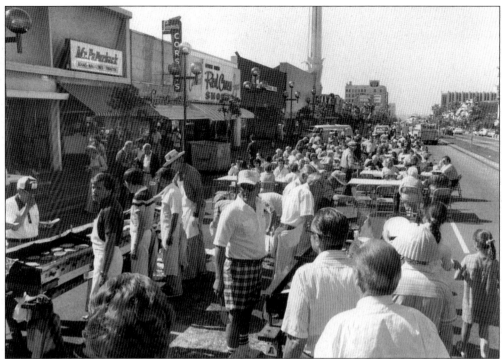

One side of Brand Boulevard is closed down for the pancake breakfast in 1980. These types of events were organized and held by local community organizations. (Courtesy of the Special Collections Room, Glendale Public Library.)

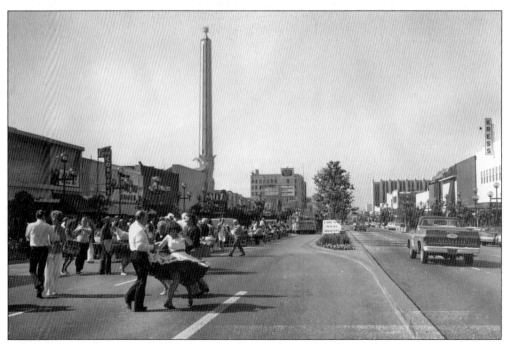

A benefit street dance was held on June 4, 1983, on Brand Boulevard. (Courtesy of the Special Collections Room, Glendale Public Library.)

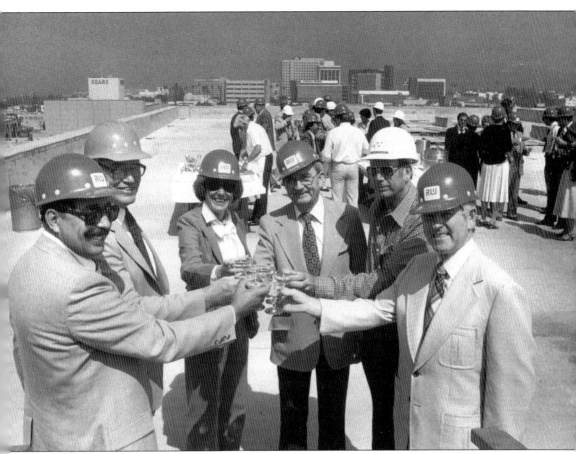

Officials toast to the Glendale Tower office building on July 23, 1980. This building brought more office space to Glendale, but instead of being near the freeway, it was located at the Galleria. (Courtesy of the Special Collections Room, Glendale Public Library.)

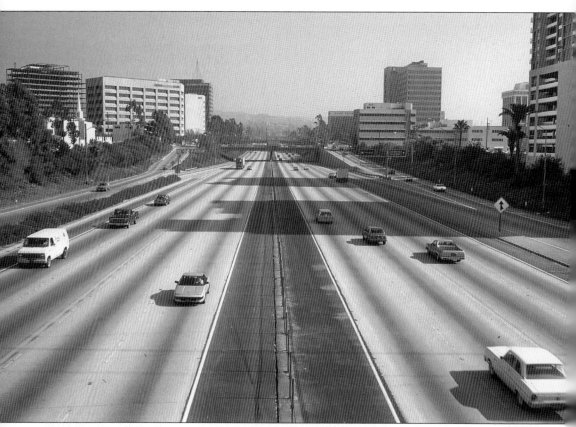

This view shows the Pioneer overpass of the 134 Freeway in 1985, with a new 13-story office building under construction at left. (Courtesy of the Special Collections Room, Glendale Public Library.)

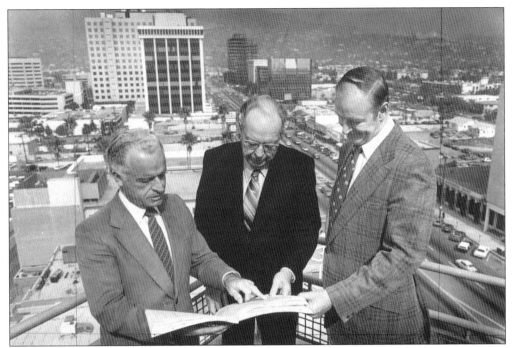

Carmen Dragon of the Glendale Symphony, city councilman Carroll Parcher, and former Glendale School Board member John Hedlund discuss events at the city's 75th anniversary in February 1981. The theme of the celebration was "pride in our progress and faith in our future." (Courtesy of the Special Collections Room, Glendale Public Library.)

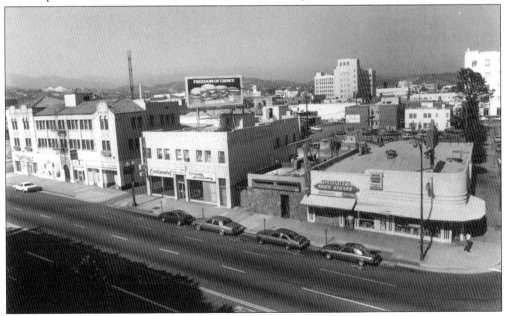

The east side of the 100 block of south Central Avenue is pictured in 1988 before demolition to make way for the second phase of the Glendale Galleria. The site included the popular Damon's restaurant and Gayson's Camera Supplies. (Courtesy of the Special Collections Room, Glendale Public Library.)

The exterior of the Rusty Scrupper restaurant, pictured in 1980, was located at 2000 Burchette Street. The restaurant was brought to the middle of Glendale's Financial Square to offer more formal dinning options to the growing business community. (Courtesy of the Special Collections Room, Glendale Public Library.)

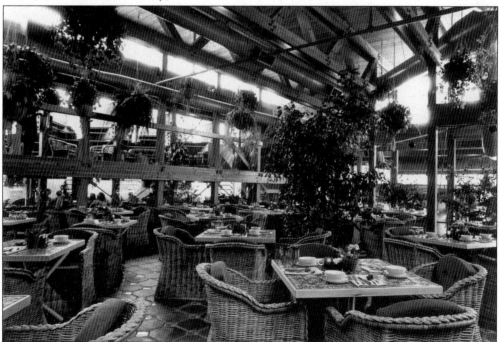

The interior of the new Rusty Scrupper restaurant, pictured in 1980, had a casually elegant décor that included large skylights, a split-level floor plan, and lush greenery to give the restaurant an airy feeling. The restaurant only operated for about 10 years before being turned into commercial space. (Courtesy of the Special Collections Room, Glendale Public Library.)

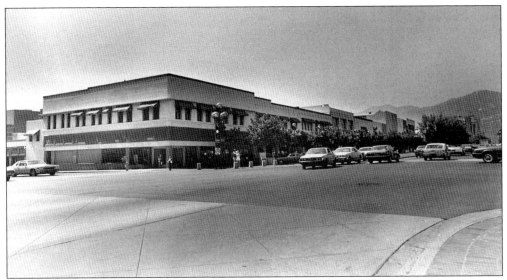

In the early 1980s, the northwest corner of Brand Boulevard and Broadway, with the old Rudy building from Glendale's pioneer days, was the subject of several development proposals for high-rise office towers. The final approved project included a set of twin office towers. One was built in 1991, but the second one was not built, partially due to a recession in the early 1990s. By 2000, the site remained vacant. (Courtesy of the Special Collections Room, Glendale Public Library.)

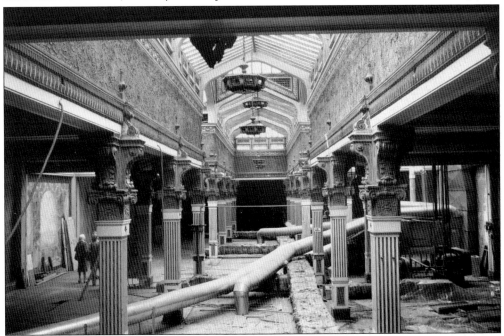

Several interest groups toured the interiors of the old Egyptian Village Café of the 1920s, which remained widely unknown from the 1940s through the 1960s until it was rediscovered in the 1970s. A wide community effort gathered to save the building from demolition, but the new owners and the city's redevelopment agency approved the demolition to make way for a set of twin high-rise office towers in the 1980s. (Courtesy of the Special Collections Room, Glendale Public Library.)

Roosevelt Middle School and Crescenta Valley High School cheerleaders pose for the camera in 1980. (Courtesy of the Special Collections Room, Glendale Public Library.)

Glendale Historical Society members Carole Dougherty, Frances Grigsby, and Audry Hales display items available at a 1980 benefit auction to raise funds for the Doctor's House restoration, which included donated labor by local residents. The Victorian-style Doctor's House was moved from its original 1880s site at Wilson Avenue and Belmont Street to Brand Park to save it from demolition. (Courtesy of the Special Collections Room, Glendale Public Library.)

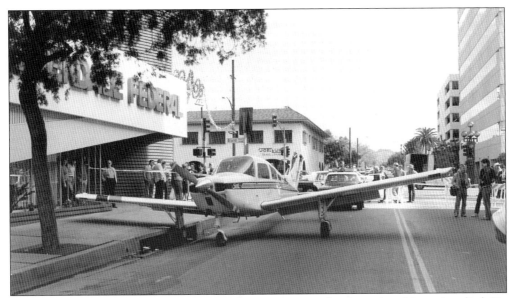

The pilot of this small passenger plane made an emergency landing when his engine died. He decided to land on Brand Boulevard to avoid the crowded 134 Ventura Freeway. Both the pilot and his passenger were found unharmed and the plane received only minor damage pictured here in 1984. (Courtesy of the Special Collections Room, Glendale Public Library.)

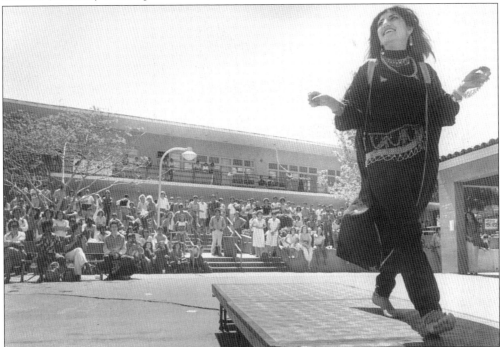

Glendale College was one of the city's institutions that tried to understand the changing population of Glendale and its student body. Inexperienced in ways to foster cultural awareness, the college conducted a costume contest in 1981 with students modeling costumes from their native land. This student displays a costume from an old Iranian kingdom, but unfortunately her costume was not the winner that year. (Courtesy of the Special Collections Room, Glendale Public Library.)

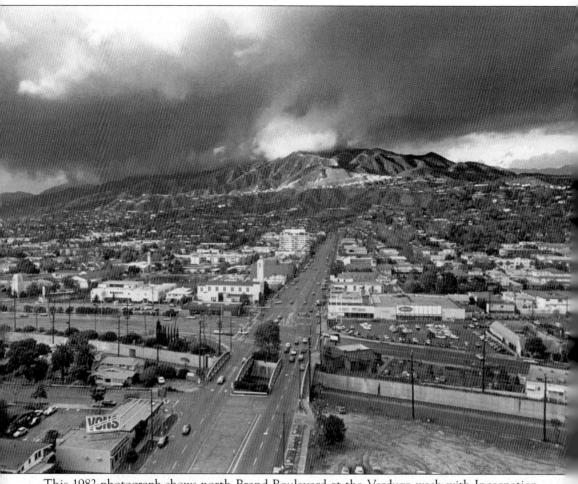

This 1982 photograph shows north Brand Boulevard at the Verdugo wash with Incarnation Church at left and the Ralph's grocery store at right. (Courtesy of the Special Collections Room, Glendale Public Library.)

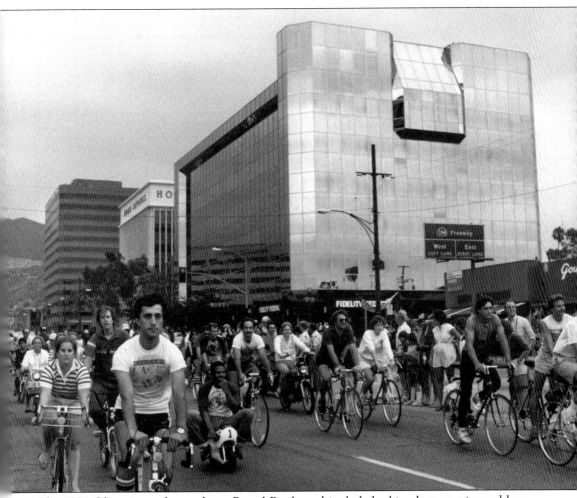

The 1984 Olympic torch run down Brand Boulevard included a bicycle race, pictured here. (Courtesy of the Special Collections Room, Glendale Public Library.)

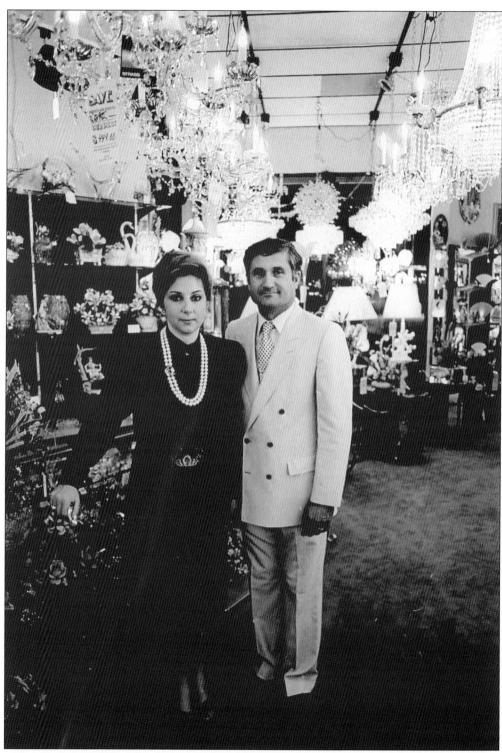

The owners of the Zaven Electric lamp store at 478 West Colorado announced their grand opening around 1985. (Courtesy of the Special Collections Room, Glendale Public Library.)

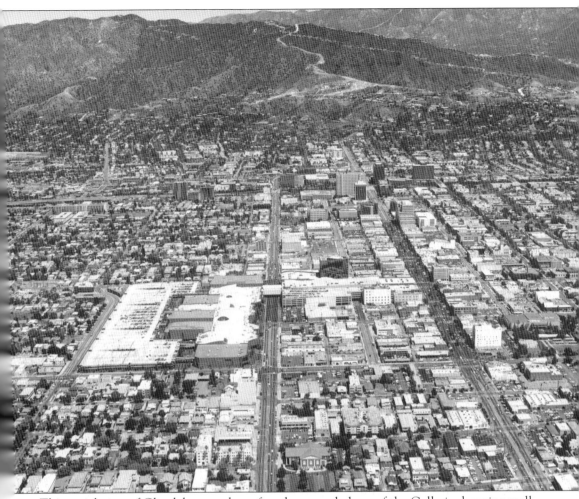

This aerial view of Glendale was taken after the second phase of the Galleria shopping mall, known as Galleria II, was complete. (Courtesy of the Special Collections Room, Glendale Public Library.)

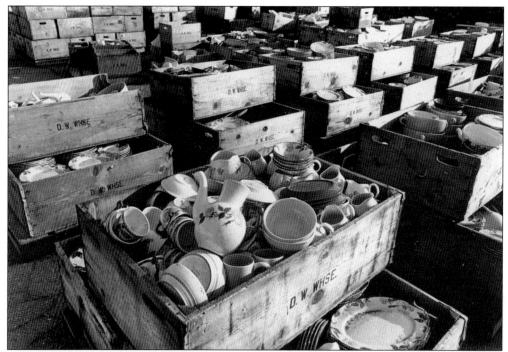

Remains of the old Tropico Pottery Works, which included various brands of pottery, are boxed up to be discarded around 1984. (Courtesy of the Special Collections Room, Glendale Public Library.)

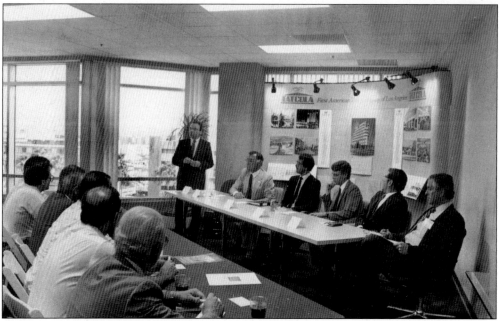

The "ideas exchange," sponsored by Doran, Platz, and Company, included, from left to right, speakers Hamo Rostamian, councilman Larry Zarian, Dana Ogden of the Glendale Planning Division, city manager David Ramsay, and architects Li Yen and Charles Walton. The panel answered questions from an audience of approximately 25. (Courtesy of the Special Collections Room, Glendale Public Library.)

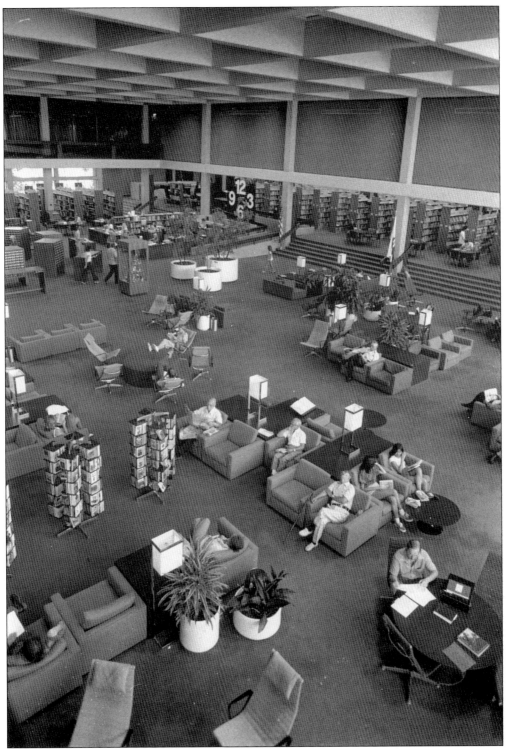

The new Central Library interior was carefully planned to provide a relaxing environment, as pictured here in 1981. (Courtesy of the Special Collections Room, Glendale Public Library.)

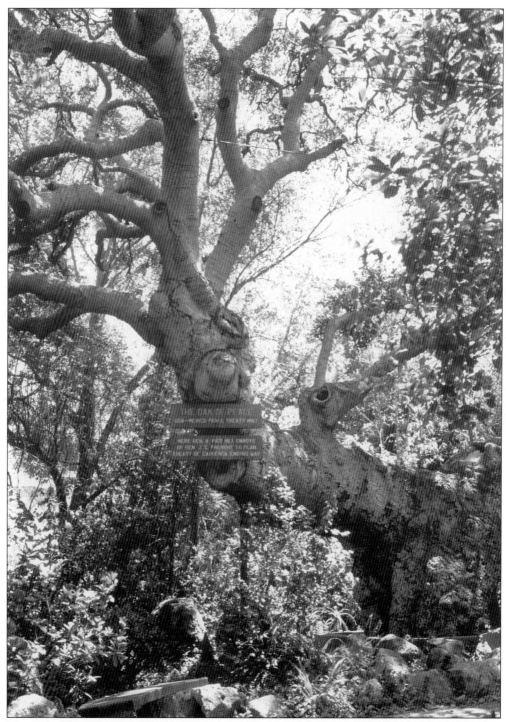

The Oak of Peace was over 500 years old when it died around 1983. Today what remains is its stump near the Verdugo Adobe. The old oak is known as the place where Mexican and American forces met before eventual Mexican surrender. It was also known as the Pico Oak and the Historical Oak. (Courtesy of the Special Collections Room, Glendale Public Library.)

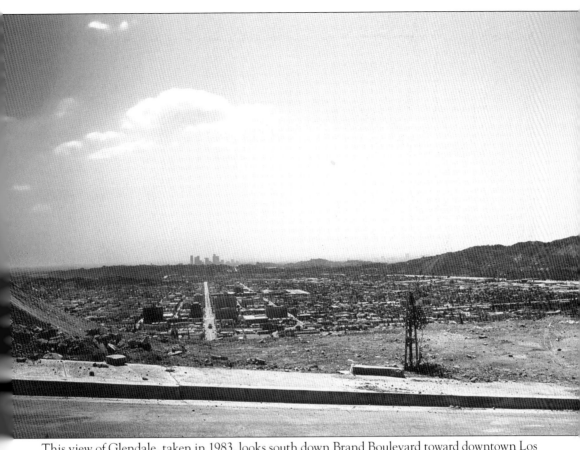

This view of Glendale, taken in 1983, looks south down Brand Boulevard toward downtown Los Angeles. (Courtesy of the Special Collections Room, Glendale Public Library.)

Dora Verdugo, daughter of Teodoro Verdugo and granddaughter of Julio Verdugo, turned 99 years old in 1981 and is greeted by Mayor Jack Day. (Courtesy of the Special Collections Room, Glendale Public Library.)

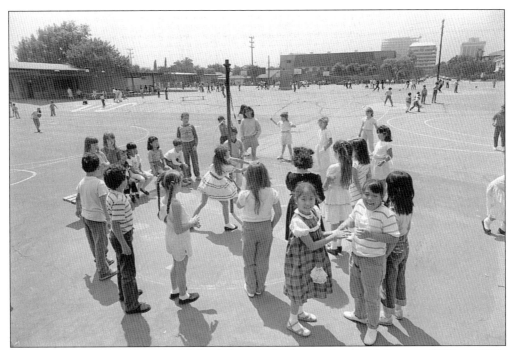

Students at Columbus Elementary School play on school grounds in 1986. Between 1980 and 1990, the student population at the school doubled, while the percentage of Latino students decreased and the percentage of Armenian students increased. (Courtesy of the Special Collections Room, Glendale Public Library.)

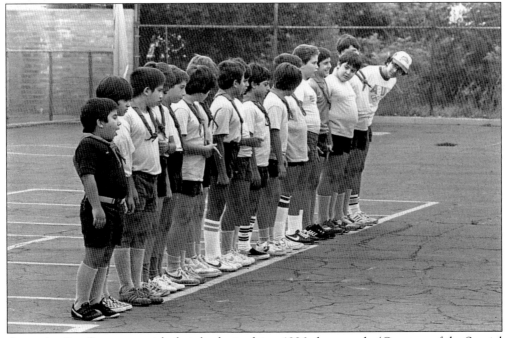

Armenian Boy Scouts are with their leader in this c. 1986 photograph. (Courtesy of the Special Collections Room, Glendale Public Library.)

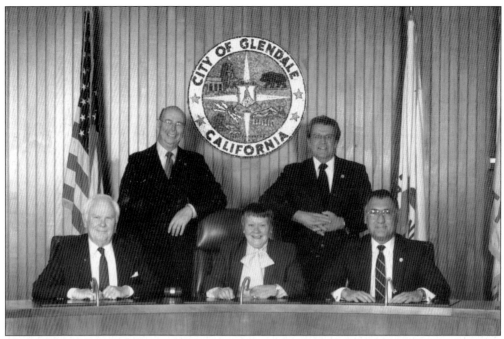

Pictured here in 1987 are Mayor Ginger Brember (center) and, from left to right, city council members John F. Day, Jerold Milner, Carl W. Raggio, and Larry Zarian. Land use and zoning were important issues that this council had to deal with when a huge apartment development boom and high-rise office development dramatically increased traffic in the community to the displeasure of many Glendale residents. Larry Zarian was known as the smooth and patient mayor compared to Mayor Ginger Bremberg, who was known as rough and outspoken. (Courtesy of the Special Collections Room, Glendale Public Library.)

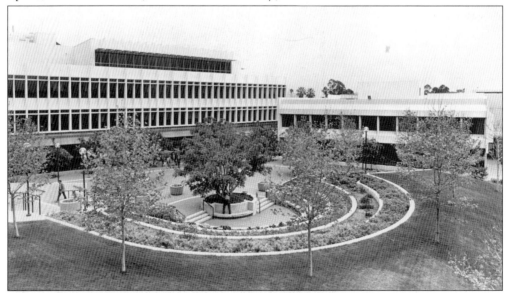

Parcher Plaza, located between city hall and the municipal services building, was named after "Mr. Glendale" Carroll Parcher and was dedicated in 1983. (Courtesy of the Special Collections Room, Glendale Public Library.)

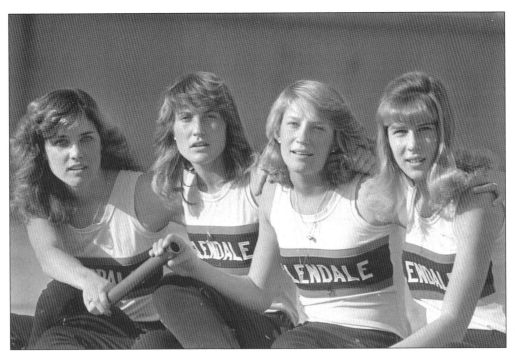

Glendale High School girls prepare for their relay race in 1983. Sports at Glendale High School have been the pride of the community. (Courtesy of the Special Collections Room, Glendale Public Library.)

Boys play in the dirt at Maple Park, which is located in the southern part of Glendale. (Courtesy of the Special Collections Room, Glendale Public Library.)

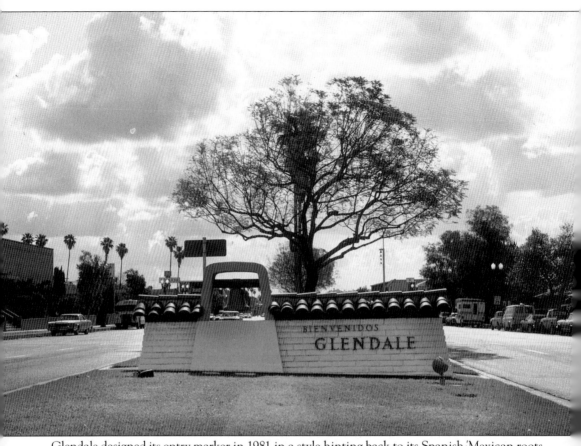

Glendale designed its entry marker in 1981 in a style hinting back to its Spanish/Mexican roots. Glendale's Latino population almost doubled in size from 1970 to 1980 to 17.8 percent. (Courtesy of the Special Collections Room, Glendale Public Library.)

Six

THE CITY TAKES CHARGE
1990–2000

Glendale had a population of 180,038 in 1990 and grew 8.3 percent during the decade, becoming a city of 194,973 by the year 2000. The beginning of the 1990s brought a recession to Southern California, but the city's office market remained relatively strong even after some weakening. The city expanded its affordable housing program, first catering to senior housing and then to family housing. A homelessness program was initiated. The city began sponsoring both citywide and neighborhood-based events.

Striving for "quality of life" in Glendale was the dominant theme in the 1990s. The city and the police department made it known that hate crimes were not to be tolerated in Glendale as ethnic tensions increased on occasion. Still struggling to create an arts and culture environment, the city created a strategy for arts in the community and a new arts commission. In the mid-1990s, a downtown strategic plan was prepared to help guide greater downtown development. New design standards were set up to help increase the quality of architectural design as a response to bad design from the development rush of the 1980s. A plan to support the expansion of auto dealers along south Brand Boulevard was adopted, protecting an important sector of the city's economy. A new redevelopment plan was adopted along San Fernando Road, initiated by federal and local plans for the restoration and transportation use of the Southern Pacific train depot completed in 1999, which became the Glendale Transportation Center. The Armenian population increased from 30,783 in 1990 to 53,854 in 2000, and with this growth came several Armenian oriented newspapers, organizations, cultural groups, and businesses. City planning focused on controlling hillside development and enhancing environmental preservation. A new official list of protected city landmarks was created in 1996.

City hall business became more dominant in the local press. The new Perkins building on the city hall campus housed a growing water and power department and community development and housing department. Carnation corporate headquarters moved to Glendale, and finally a major hotel was built. The city looked for big retailers in the early 1990s, but was happy to see new studios wanting to move into the city. Glendale's economy diversified when ABC studios, DreamWorks, and the planned Disney campus in the old Grand Central Industrial Center called Glendale home. Talk of a local Armenian Genocide memorial increased through the decade, starting with memorial events at the Glendale Public Library. City government stepped up to recognize ethnic diversity by creating the city-controlled human relations coalition for the community and a human relations committee for city employees. In 1997, Glendale started to televise its public meetings, increasing the opportunity for residents to get involved in local government.

This panoramic photograph looks across Montrose toward the Verdugo Mountains, showing the approximate location of the proposed Oakmont V subdivision of over 500 single-family homes to be built along the hillsides facing Montrose and La Crescenta. (Courtesy of the Special Collections Room, Glendale Public Library.)

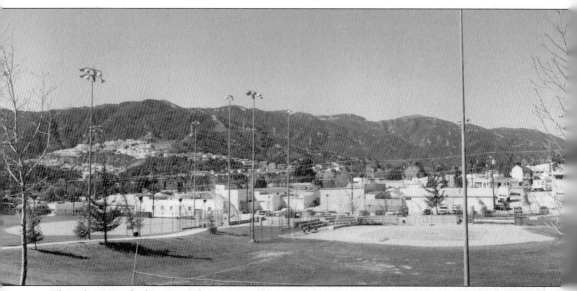

This photograph shows another view of the proposed location for the Oakmont V residential subdivision, seen along the center mountain range behind Montrose Park. A strong community objection forced the city and the developer to look for other options. (Courtesy of the Special Collections Room, Glendale Public Library.)

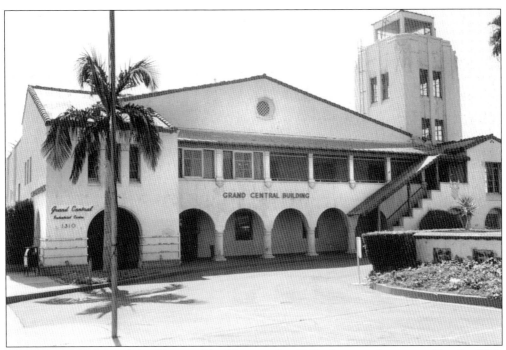

The old Grand Central Air Terminal building in this 1998 photograph is owned by the Walt Disney Corporation. (Courtesy of the Special Collections Room, Glendale Public Library.)

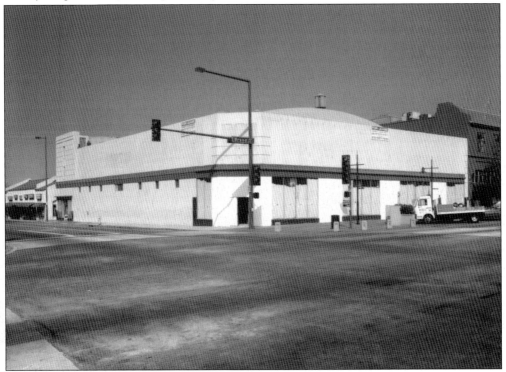

A second story was added to the old Woolworths building to house the new home of the *Glendale News-Press*. (Courtesy of the Special Collections Room, Glendale Public Library.)

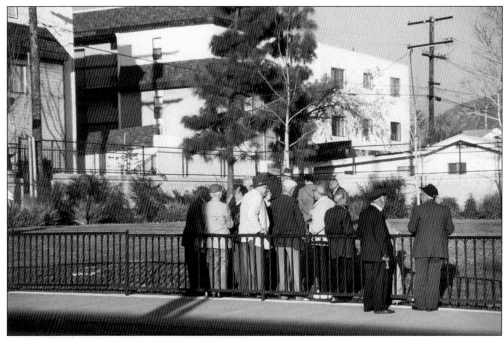

The Wilson Avenue minipark was one of the city's first to provide a small outdoor area for residents within close walking distance. After this photograph was taken in 1995, outdoor seating and play equipment were installed. This park has proved to be very popular with older Armenian men, who play games and talk about the old days here. (Courtesy of the Special Collections Room, Glendale Public Library.)

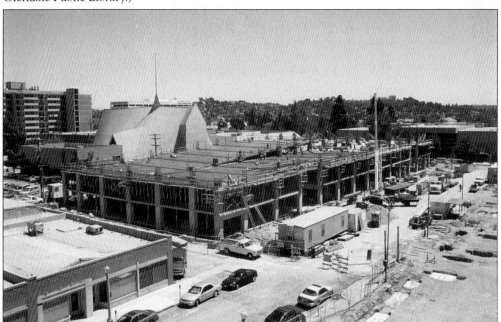

The Marketplace project was one of the redevelopment agency's most heavily subsidized projects. It was intended to be more of a lifestyle- or pedestrian-oriented center that was popular in the mid-1990s. (Courtesy of the Special Collections Room, Glendale Public Library.)

The monumental Art Deco public service building, designed by Alfred Priest and found to be eligible for the National Register of Historic Places, was demolished in 1993 and replaced with a landscaped plaza within the city hall campus. The city council approved the demolition after a battle with a coalition of local groups. The city claimed it did not want to pay for restoring the building that was constructed in 1929 and that it was too close to the planned Perkins building. The original light fixtures were saved and placed on the city's light and power building and the original bronze plaques were reinstalled in the plaza. (Courtesy of the Special Collections Room, Glendale Public Library.)

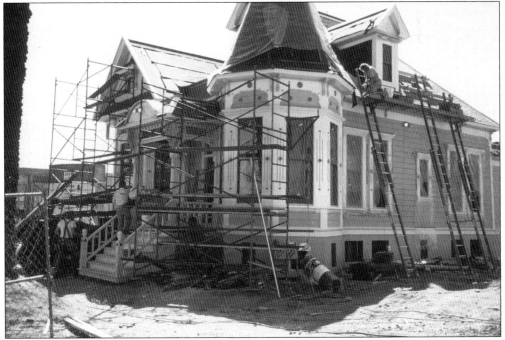

Goode House was saved and restored by the city's Community Development and Housing Department in 1995 and used as the recreational center for the new housing development surrounding the house. (Courtesy of the Special Collections Room, Glendale Public Library.)

The grand Alex Theatre was purchased by the city and restored by the Glendale Redevelopment Agency to become the focal point for cultural arts in Glendale. In 1995, the Glendale Symphony moved its home from the Dorothy Chandler Pavilion to the Alex. (Courtesy of the Special Collections Room, Glendale Public Library.)

Bride Rima Arakelian and her wedding party consisting of her sister and three cousins pose for photographs in front of the Casa Adobe de San Rafael in 1994 before heading to St. Mary's church for the wedding. (Courtesy of Rima Arakelian)

A small stream is a part of the former Oakmont V subdivision project that is now a preserved environment of the Verdugo Mountains. (Courtesy of the Special Collections Room, Glendale Public Library.)

Angela and Karo Boiladjian pose in their christening outfits outside the Brand Library, looking down Grandview Avenue. (Courtesy of the Boiladjian family)

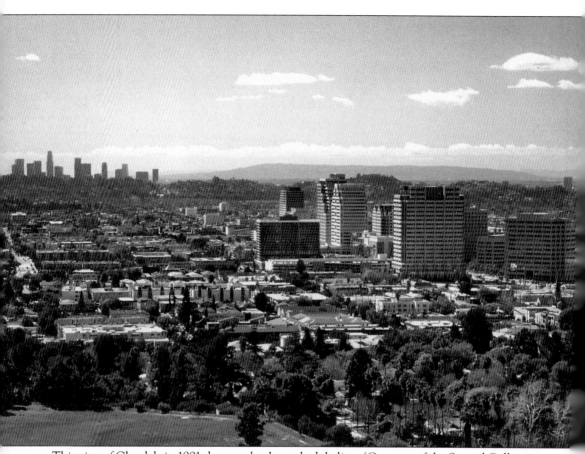

This view of Glendale in 1991 shows a clearly marked skyline. (Courtesy of the Special Collections Room, Glendale Public Library.)